Our Father, which art in heaven,
mellow be thy name.
Thy midnight come,
thy will be shunned,
in Chi as it is in this club here.
Give us our jams, our nightly beat,
and forgive gals who won't dance against us.
Lead us straight into temptation
and deliver us from women who are evil.
For mine is the dance floor, with its power and its glory—
Amen.

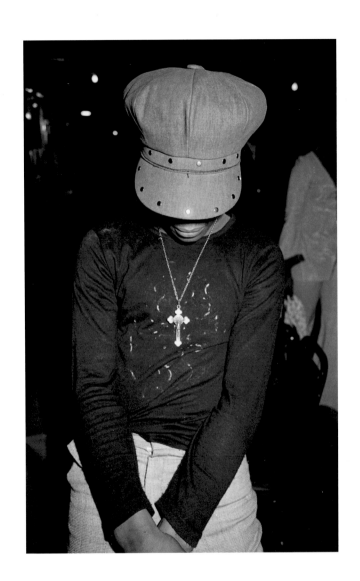

CITYFILES PRESS PRESENTS

Gotta Go

Patricia Smith

POEMS

Michael Abramson

PHOTOGRAPHS

Gotta
Flow

Life, Love, and Lust

On Chicago's South Side

From the Seventies

All photographs © Michael Abramson
Patricia Smith's poems © Patricia Smith

Project created, designed, and produced by Richard Cahan and Michael Williams

Published by CityFiles Press, Chicago, Illinois
www.cityfilespress.com

ISBN: 978-0-9915418-2-9

1ST PRINTING

Print and color management by iocolor, llp Seattle
Printed in China

Michael Abramson took these photographs with the full knowledge and consent
of patrons in and outside five nightclubs on Chicago's South Side during the mid-
1970s. Patricia Smith used these photographs four decades later as an inspiration for
her poetry. Although the photographs in this book are of actual scenes, the words
appearing with the photographs are fictitious. They are meant to capture the mood of
these clubs. Any resemblance to any persons, real or dead, is purely coincidental.

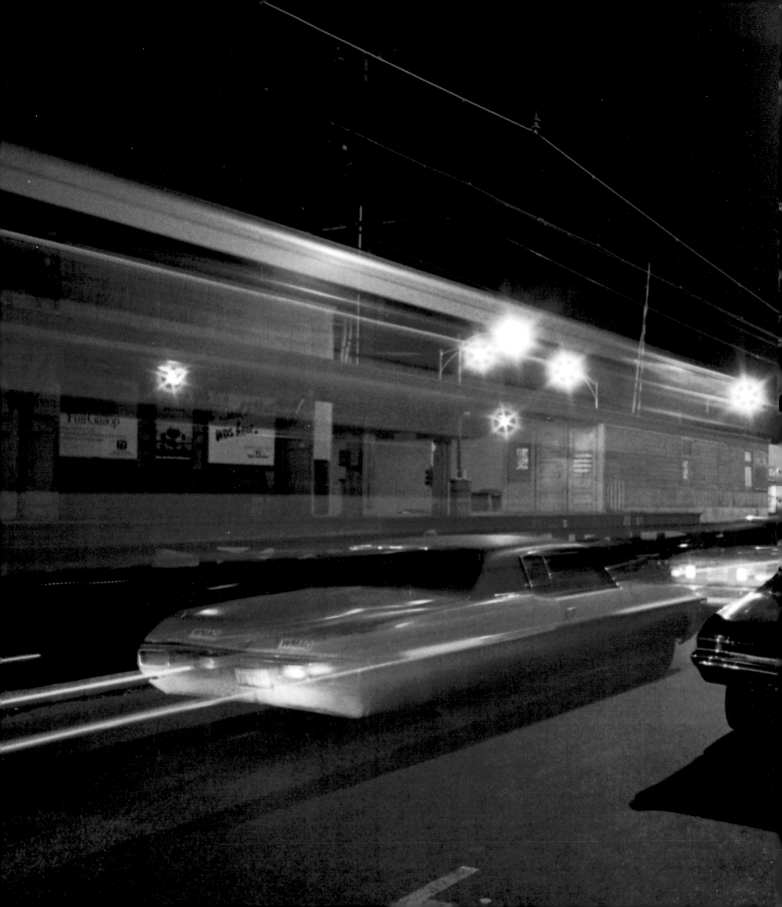

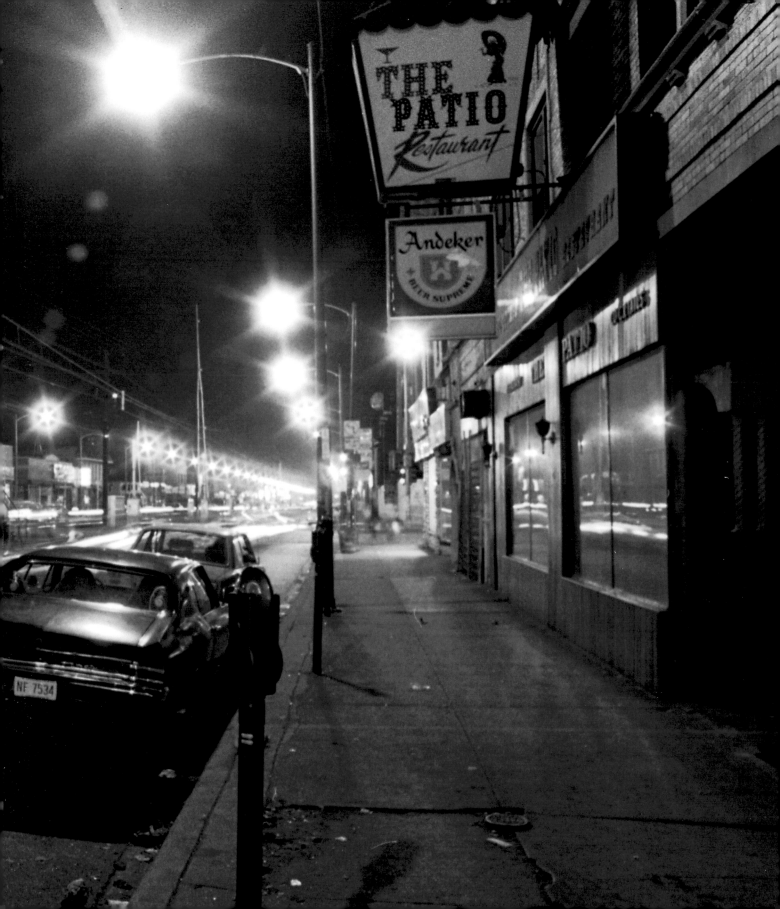

Damn. Nighttime Chicago hurtles through its hours without apology or grace. It's a blur, a warbling blue note barely witnessed, a smear of neon. Most mornings you can spot a few dazed stumblers wondering if it really ever happened at all. But then it comes back, hazy and slow, like a dream that couldn't possibly have root. It happened. And it happens. The night is relentless in the way it comes every night.

It comes like this: Knife-nosed sedans poke down the boulevard, windows down, slow so everybody can see. Iron bars are pulled across daytime doorways, and neon signs begin screaming for their wicked audience. Even in winter, when Chicago is a backhand slap across the face, the temperature rises a little when night comes. The sidewalks steam. This is a city poised to accept what hungers in you.

You walk into Chicago's darkness without armor. You walk into it blind, praying it will teach you how unreliable eyes can be. The Windy's night is all about the sass of those other senses: whiskey's flammable screech in the mouth, its claw down the throat. The tingle of bassline in the butt and belly. Gutbucket riffs so blue you can taste them. The ceaseless rumble of love talk, shit talk, real talk. The first touch from a woman whose body is known before her name—the ripple of warmth that touch leaves on the skin.

The club only dons the cloak of shelter. The slick havoc of the boulevard is on both sides of the door. But inside, it pretends a softness. Men coo practiced lines and burrow their fingers deep into mink, into the undulating waves of a woman's hair. Sweet young things lean against the jukebox and hum melodies that remind them so much of hymns. The drinks lining the bar are pink, scarlet, amber—slow colors— and as the evening starts, the sound of easy sipping mingles with the music, and ice clicks gently in stout glasses. The marquee blares the names of where rhythm comes from. And what there is besides rhythm—fried perch, chicken wings, smothered pork chops, chitlins, sides of potato salad or collards, fuel for the night to come. The club insists on being its own kind of real.

The name of the club? It doesn't matter—Perv's House, the High Chaparral, Pepper's Hideout. What matters is its wide-open door waiting for what the darkness has conjured. Here comes the seasoned player, silver Afro dimpled with starlight, pimp-steppin' with a lion-tipped cane bearing his weight. Here come those gap-toothed gals born in Alabama or Mississippi, corn-fed hips threatening the seams of their first real Chicago outfits, two sizes too old and fresh outta Lerner's layaway. There's that brother who wears heartbreak for a hat, looking, for once, to leave with someone other than himself.

Oh, and there's the sissy boy, pompadoured and perfumed, grateful for this one place he can throw his head back, wail his wail, dance with his own damn self.

Coming right in behind him is the preacher, convinced that this just might be the place to save souls, beginning with his own. Here come the dancers already hot at the thought of downbeat, the midnight merchants with their cardboard boxes of Pimp Oil and drooping roses for the ladies, the kids in their grown-up skins, the beauty queens, the drunks, the crooners, the strippers, the triflers, the failed, the famous, the flawless.

Here comes the DJ. Here comes Howlin' Wolf, Tyrone Davis, and Lonnie Brooks, all ready to be blue. Here comes the 1970s with its bejeweled fist raised in the air, with its bottoms belled and its 'fro picked out to the rafters. Here come black folks as royalty, making their mark on a hard city. Here they are in a palace that's just theirs.

And, right on time, there's that white boy lugging that camera again.

Once everyone is in, the door to get out disappears. Whole lives are lived and surrendered between the hours of 10 and 2

or 10 and 4 if you're lucky enough to get into Perv's. The drinks get harder, the music funkier, bodies push and push. The night, which is never long enough, goes on forever.

Until something called morning. Shuttered, the club loses its nighttime breath. Beneath the whole of Chicago sun, which has a tendency to blast down blue and irritable, the paint curls; doors are gated behind Woolworth's padlocks; dirty panes rattle in splintered frames. The dimmed marquee squeaks sweet, the names of the midnight chosen still lit from behind by a gone moon. The sidewalk is day ugly with stubbed Luckies, plastic cups, matchsticks, and crazy splotches of whiskey spilled in glee or vex. Maybe a woman idles by, pushing back half a gold grin, remembering the other she was the night before, wrecked by B-16 on the juke and something thick and scarlet slurped through a straw. She snorts a giggle, remembering her feigned collapse against a succession of sweet-smelling hims.

During the day, the whole hood rotates around the club. Young'uns stare wistfully at its bass-driven promises, always just outside their reach. Every night, promises—both broken and fulfilled—whirl in cool black and white under a mirror ball that spews dreams.

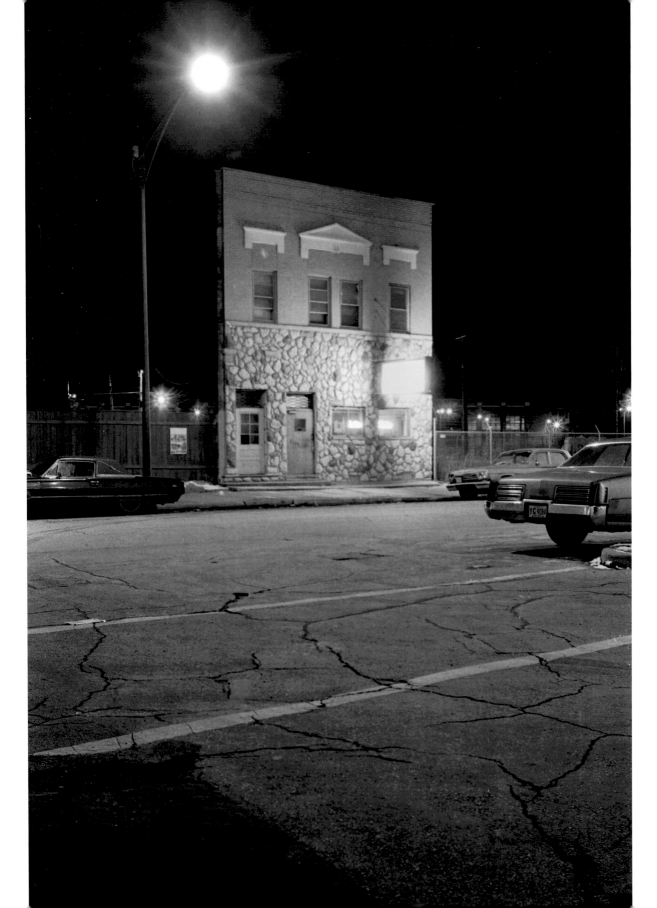

This is the sweat they prayed for. This is the slow roll,
the thrust, the all-up-in-it, all that greased hair
going back where it came from. This is the cocked-brim
felt fedora bouncing, the patent high heel buckling,
the panties shifting on electric bodies. What's here
is the unleashed swivel, and, every other song or
so, a hissed promise of pump, quicksilver romance.
Don't lose your partner—keep her voltage in view,
keep one wet hand on his vibing hip, tie yourselves
together at the downbeat. Close your eyes and know
the possibilities of your own body, beg the DJ to hold
you tighter, let you go, hold you tighter, let you go.

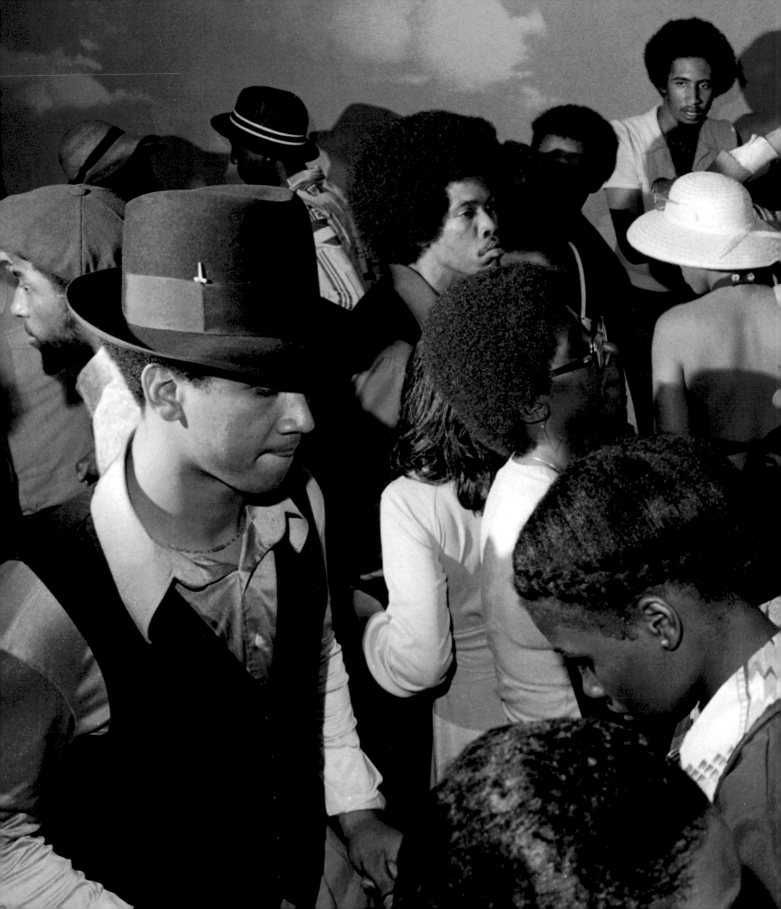

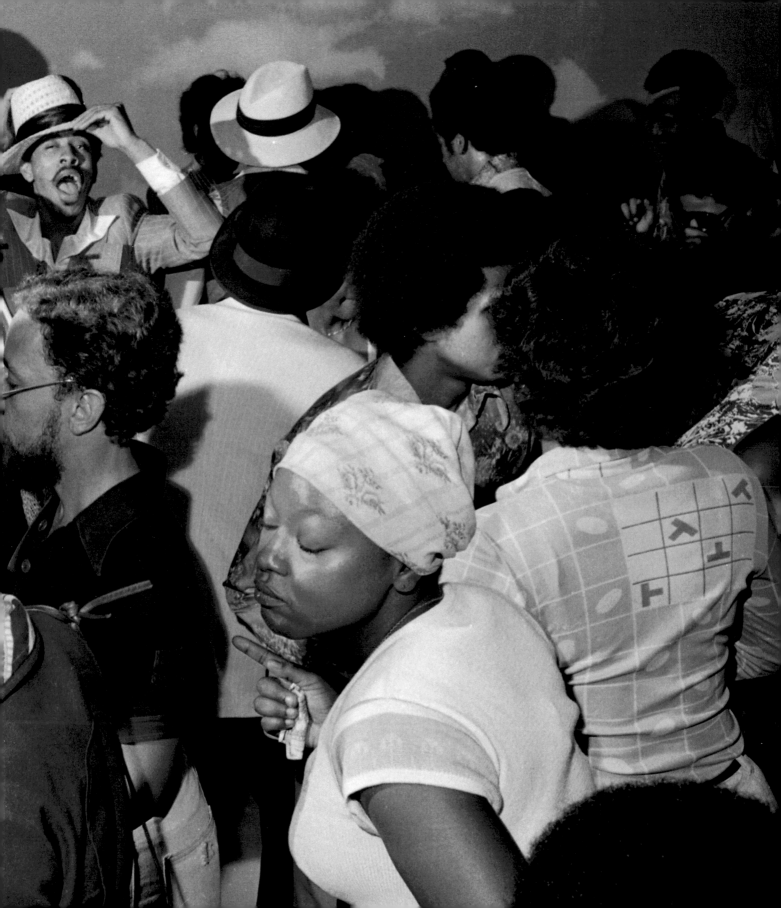

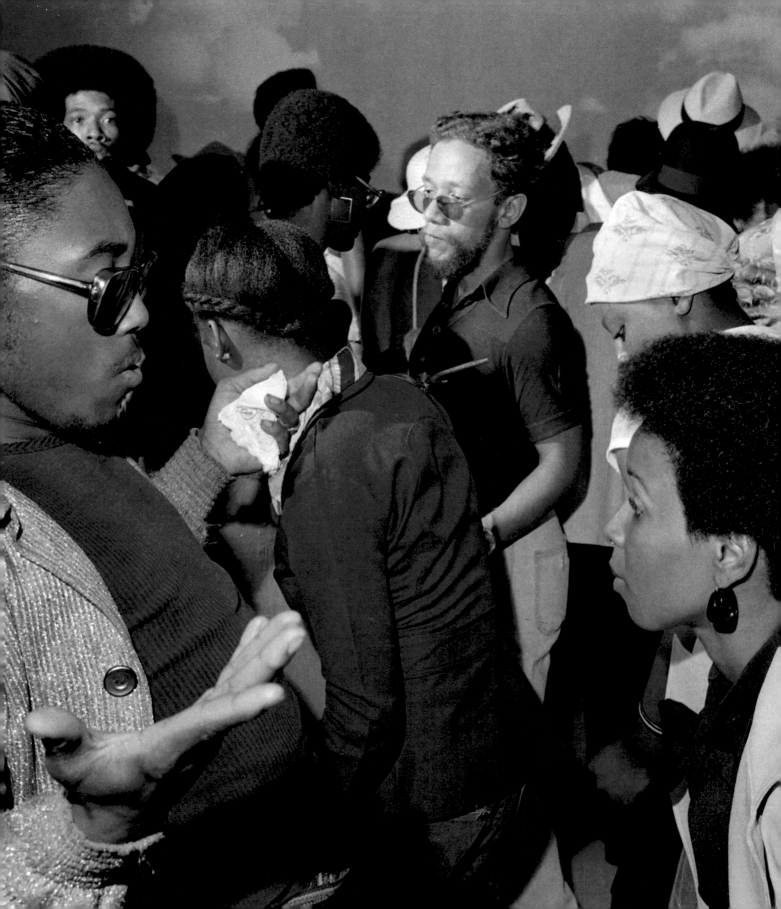

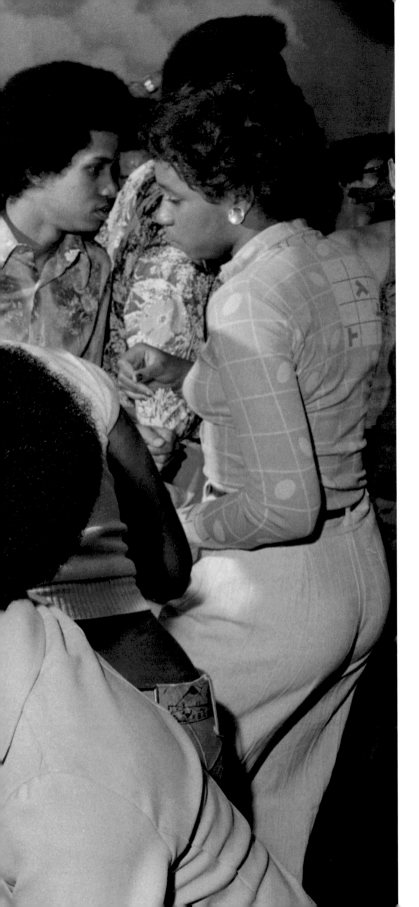

You are slave to deep bell, conch shell,
goat nails, and the drum's tattooed skin.
Your body was crafted for this. Hips try
on their fluid. Writhe, slither, then break
funk down to its denominator bottom:
Bead. Grunt. Cymbal. Grind. And crash.
If you still need to give it a name, find
a word the world isn't using, a sound
keening, pulsing way below the bop of it.
They say black people are linked crazy
to the drum, that they don't know how
not to answer when the drum calls—
Gotta go, gotta flow, gotta know right now
what that fuel is. Gotta go, gotta flow,
gotta blow blue through flute and spittle.
Let your hips be your engine. Move in.

This is what she came for—the head thrown back,
the drenched breastbone, gutbucket notes going directly
to the backside. It's the blatant redefining of joy
when nothing outside the door can get in—no Hawk,
no clacking factory line, no quick blades or empty
wallets. This is what she came for—the dance that
changes from sway to engine, the dance that doesn't
end, the love he probably doesn't have left to give.

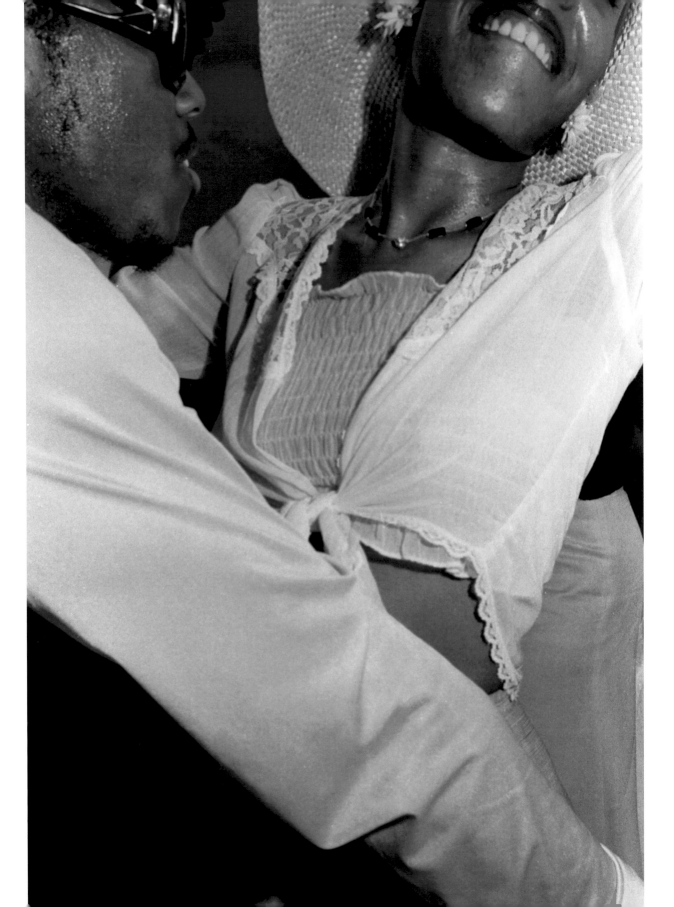

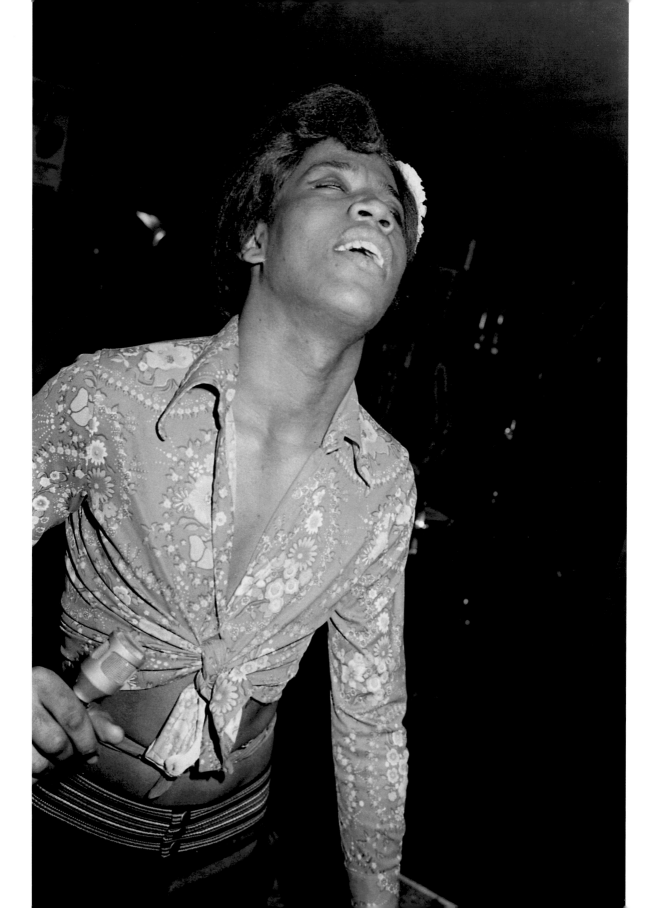

I am slipsilver spine, the persistent drumbeat
of peppermint and diamond, all the cool this
particular corner of this particular room can
handle. Eyes drawn siren and lips defined,
I aim to sing you into another lifetime, I plan
lurch and shimmy the way my mama taught
me. There is nothing you can do with this but
witness, nothing you can do but stand aside.
I eye-roll and tender-click my hips, revving
a floral engine, and I tease you with the mic
while flagrantly having the night you wish
you were having, all the while looking damn
hotter than the woman you wish you were with.

Boogie is balance, down low.
It is dangerous in its purpose.
It is so serious that dancers
risk lives. Their intent is evident.
They dance to save their lives.
They waver on the edge of cliffs.

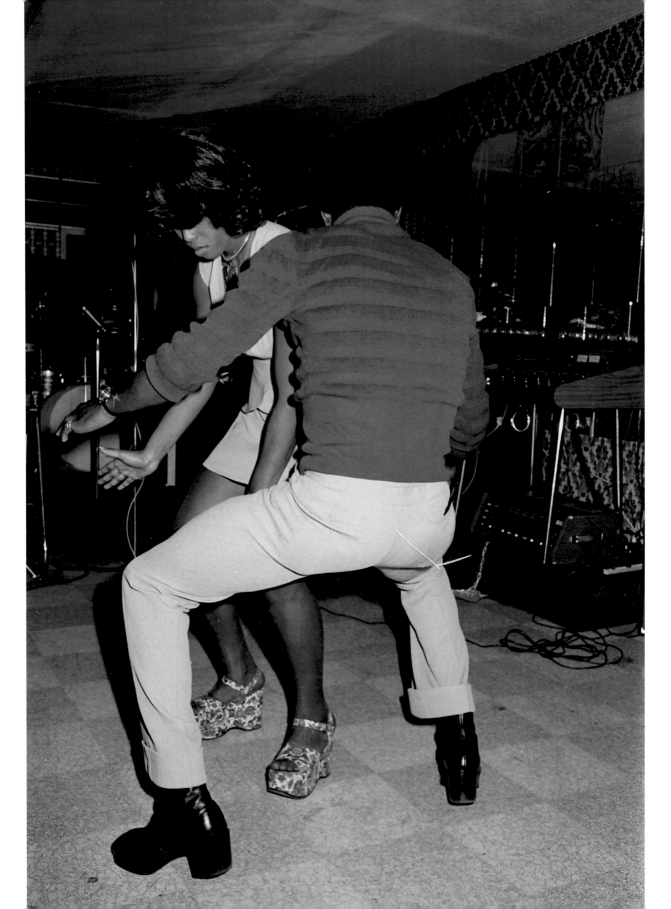

The slow *waka waka* porn beat, the one smashed bulb,
the funk, the whole funk, and nothing but the funk,
the deluge, the body memory doused in red dust,
conjuring the dark cadence of where dance comes from,
the sun losing its damn mind, the sheen of shot glasses
hefted, the outline of oiled hips and the slow ride down
the body of the room, something is leaking that could
be a church and the boom is all you can breathe.
Must have left a spine on the 79th Street bus. Gracing
the stage with the stamp of sweet stank, there's a slow
turn to fluid, then back to this danger. Even the women
gasp when the whole body is banged from standing to split.
That's when all the men look. Before they look away.

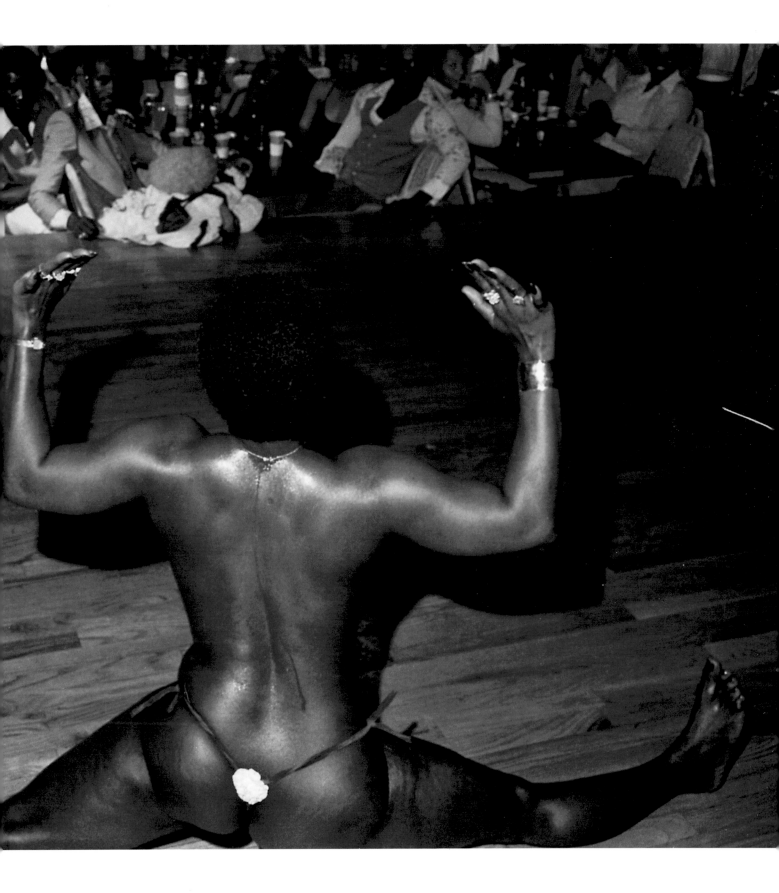

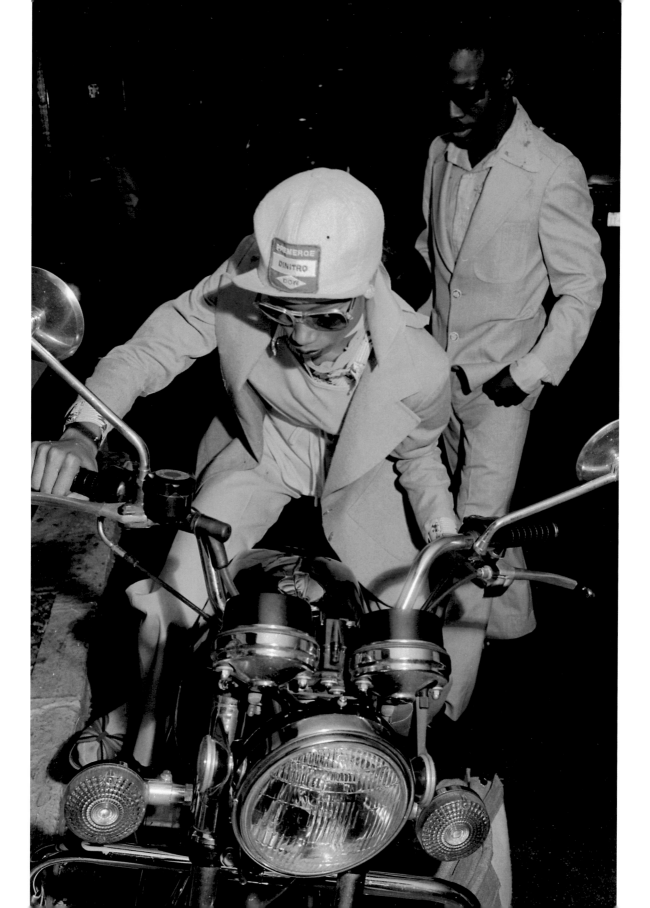

Who needs a Cadillac or Deuce and a Quarter,
a Lincoln Mark, all that clank and gas money?
Once you know what's it's like to feel an engine
groan and grow right through your hips, once
you zoom up to the club, cracking the curb
with your own chill, once you figure out how
to stand the funky perfection of your own arrival,
once you know the sugary addiction of making
a scene, who needs to zoom backward into
regular, into *just like you,* into ordinary again?

No feedback tonight. It's been weeks since this mic's been workin'—when it buzzed at all, it popped *p's*, bended voices, or slapped them all the way shut. But now every sound comin' outta the thing is like God moaning a moan in your ear. Every blues rumbles in the belly, and all of a sudden colored folks— who don't give up their seats for nothing but a wildfire—tip murmuring into the room to be close to the gospel that mic's turning everything into. But damn, here he comes. He grabs his harp, and it's all over. That first note rises sweet and rude like a star in the daytime, and he turns bloodshot eyes up to the Lord, straight up thanking Him for sound. So now nobody's going nowhere. Nobody knows how long that mic's gonna be hot, and that man got a hundred blue songs in him. Go 'head and lock the doors.

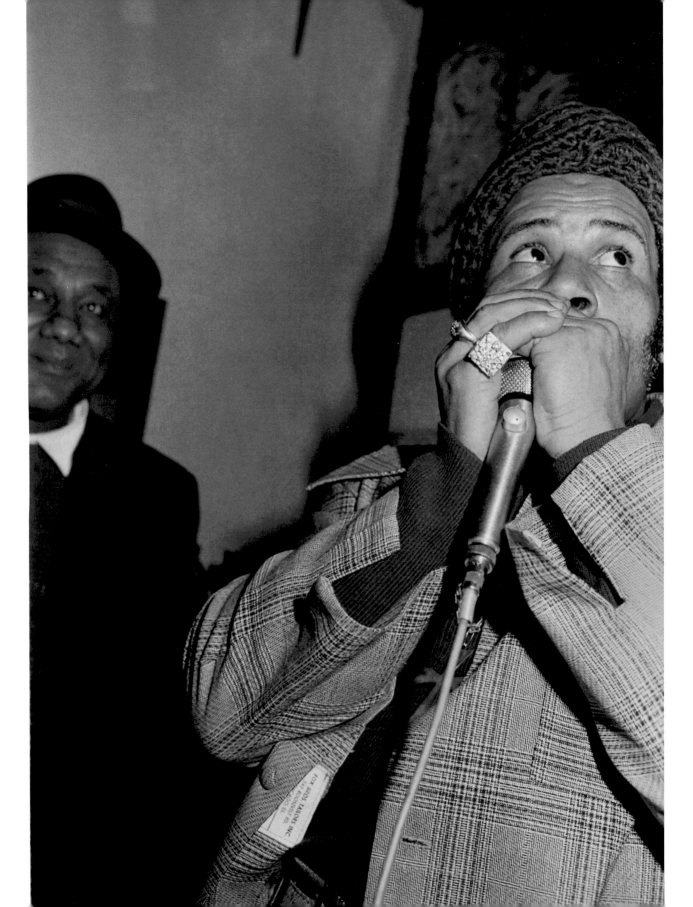

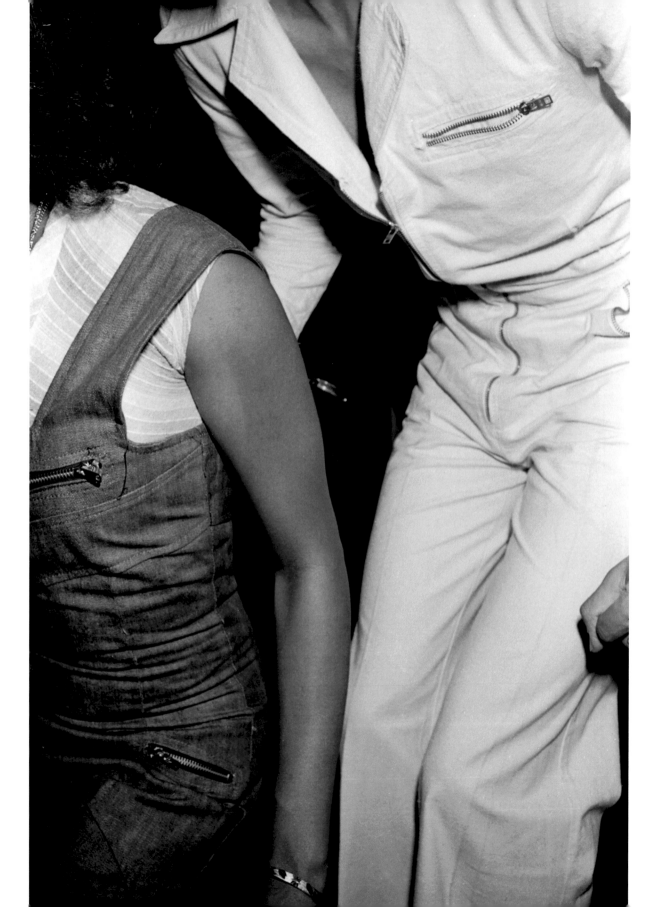

Dancing is the name of what fits where.
It's that grin/grimace when a pinpoint of friction
becomes all there is. It's amazing how drums
sign every contract at once, how heat threads
with heat and all of a sudden everybody forgets
all that time in the mirror, tweezin' and primpin',
all that pretty they were when the night began.
Dancing is him in that instance of conquest, body
poised to receive and receive. It's her doing
her rushed math, hoping the angle is perfect,
not daring to turn around. Dancing is them,
stunned in the worst perfect moment, hoping
those drums don't stop, don't stop, don't stop.

When the funk takes hold
When the funk takes over
When the funk won't listen
When the funk keeps yapping
When the funk finds its swivel
When the funk rules the room
When the funk is your mistress
When the funk is your god
When the funk got the gospel
When the funk is your woman
When the funk reaches for bone
reaches for pulse
reaches for your rumble
reaches for crevice
and finds
you
and enters
you
and conquers
you
there's nothing to do
but give
what you got

to the room

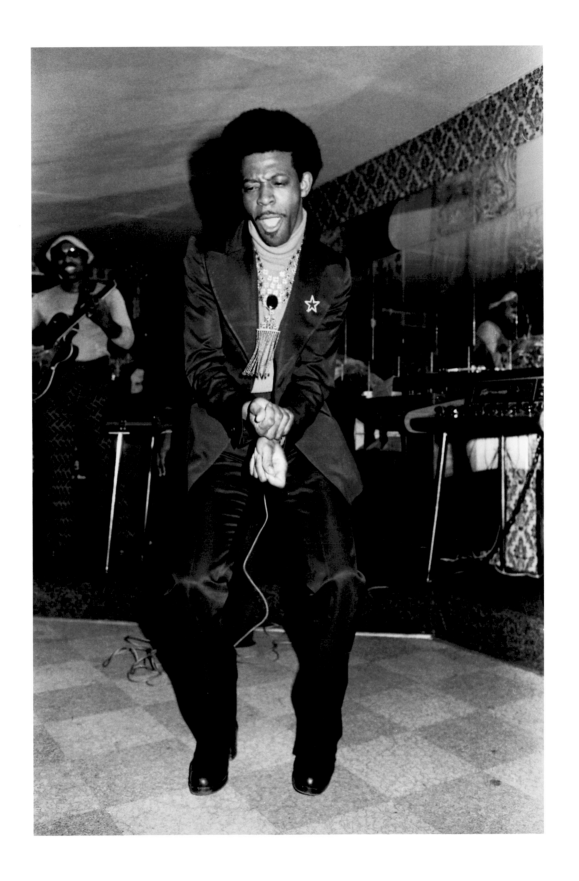

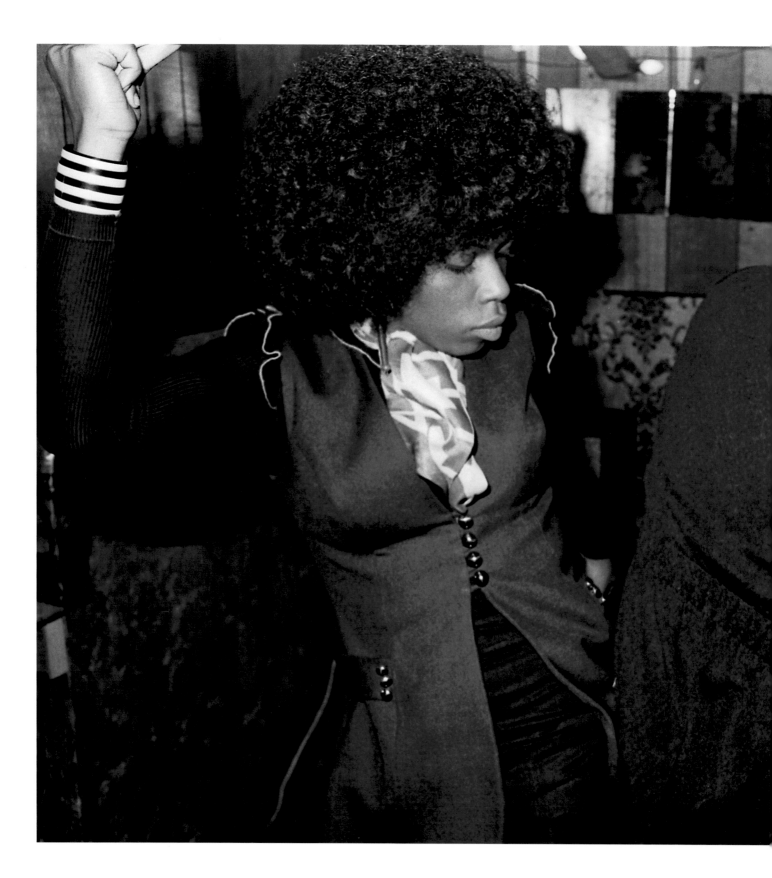

the bump was created
to give two bodies
an excuse to become one body
at one little pinprick of heat
think about it you are hitting
a stranger with the business
of your hip
then backing away gathering strength
and banging hipbone yet again
and twist and again
until one or both of you
get creative or desperate
and dip just before the point
of impact
so that that bone
smashes into the pelvis
or a knee
pokes its way between sweaty legs
and a line
that nobody drew
is crossed

the bump was created
to give two bodies
an excuse

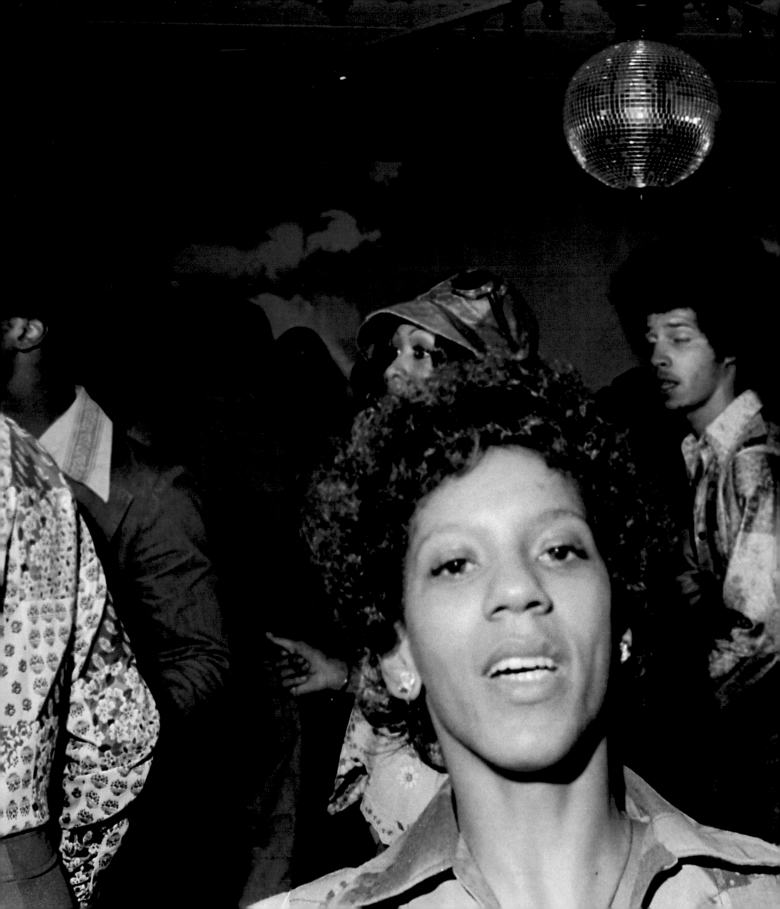

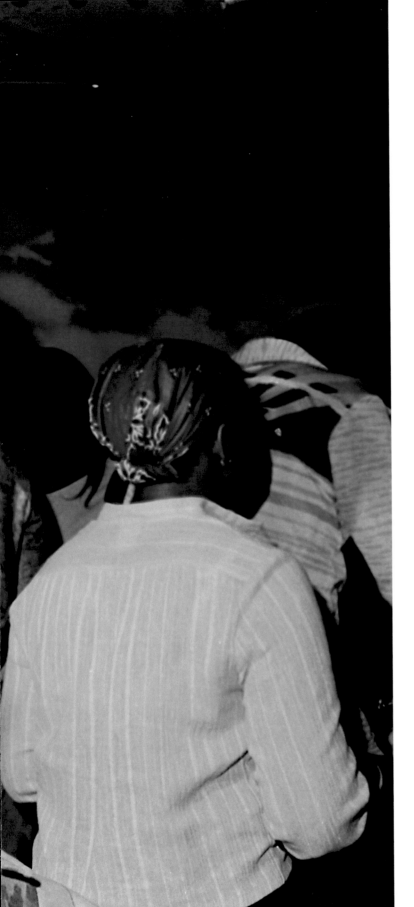

What exactly does a mirror ball do?
In a room this dark, it disappears.
What magic it claims is diluted,
swallowed by shadow and backbeat.
Its one job is to plunge the whole room
into a vat of magic,
to fade scars, whittle waists,
bless with rhythm,
to make that third drink sound
like a really good idea.
But in this cavern of *boom boom boom*,
it's merely decoration,
a little bit of glass gone crazy.
Nobody remembers its lonesome twirl
above their heads.
But later that night, no one who was there
can sleep, because the night
came home with them,
and it won't stop spinning.

I Ain't Never Left Anywhere Alone

Chicago men got a swagger that says they
know alleyways and a hundred ways to tame
salt pork. They know how to cut loose, how
to double a negative and clear a room,
Chi-town men mean every explosive thing they
mutter to a woman. The shock in their words
is real. They smoke a sweet particular poison.
Afraid that the eyes might really be windows
to the soul, they wear shades smudged dim.
Behind the glasses, their wants are wide open.

Chicago women got a swagger that says they
know the ways of Chicago men. They come up
in the shadows of lumbering boys, the women
built themselves up on doubledutch and swigs
of cooking grease from sinkside jars. When they
dance, their unbridled hips bellow like fists,
overwhelming whatever the music thought it was.
What did the music think it was? In charge.
But no Chicago woman has ever met a dance
floor, or a man, she couldn't buckle and break.

She smiles because she knows that.
He smirks because he doesn't.

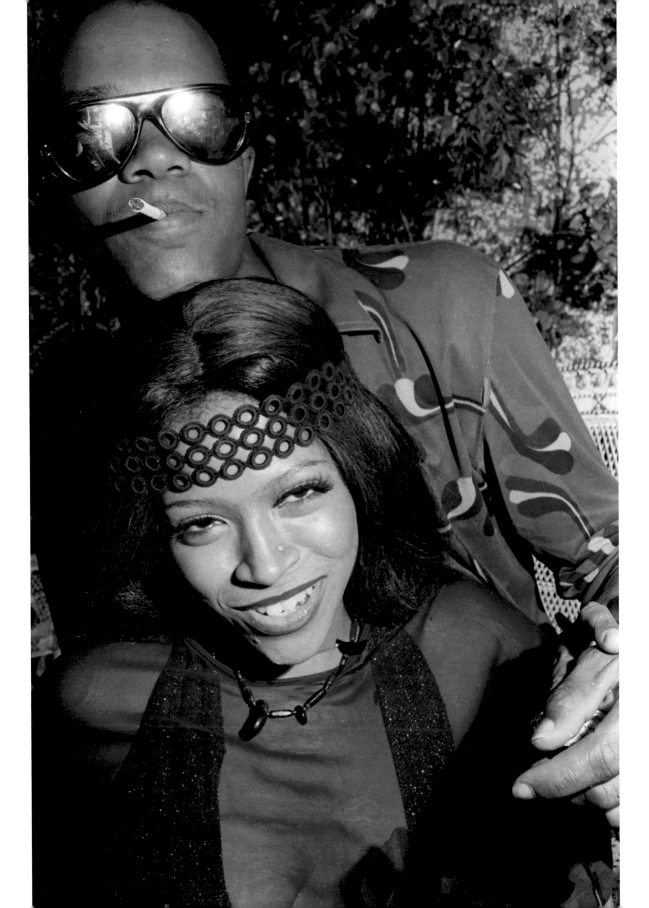

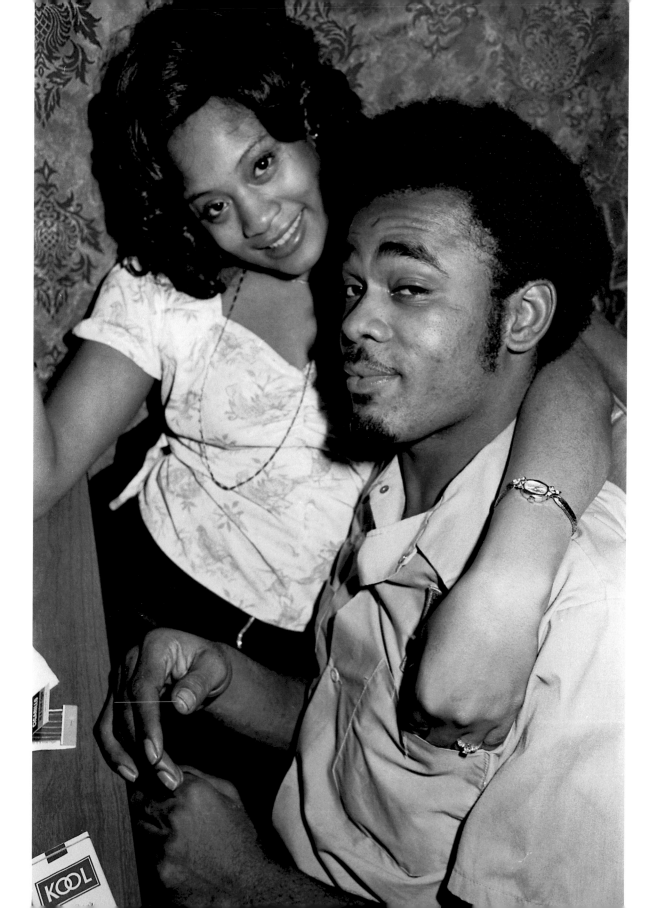

There ain't no love like love in the club,
seeing that it's only for one night. But it's
everything it can be in the time that it has.
There isn't even need for the exchanging
of names—*baby* is always more than
enough. Love in the club is the mingling
of dime-store sweetness splashed onto
both necks, it's the well-timed cigarette,
the warmth rising from a single shared
space. It's knowing, without a doubt,
where the night is headed—and doing
whatever you need to do to get there.

I don't dress practical, I dress royal, I strut beguiling,
I primp for praise. I am neon stripe and fur, texture
and sheen, I smell flowers that exploded.
I was born with a thousand arms, and there's a woman
waiting for her place inside every one of them.
I squeeze them until breath is no longer necessary—
as long as I'm touching them, they got reason to live.
I'm the extra in extraordinary,
so bad I'm jealous of myself sometime.
Line forms to the left, darlin'.
Ask anybody. The wait is worth the wait.

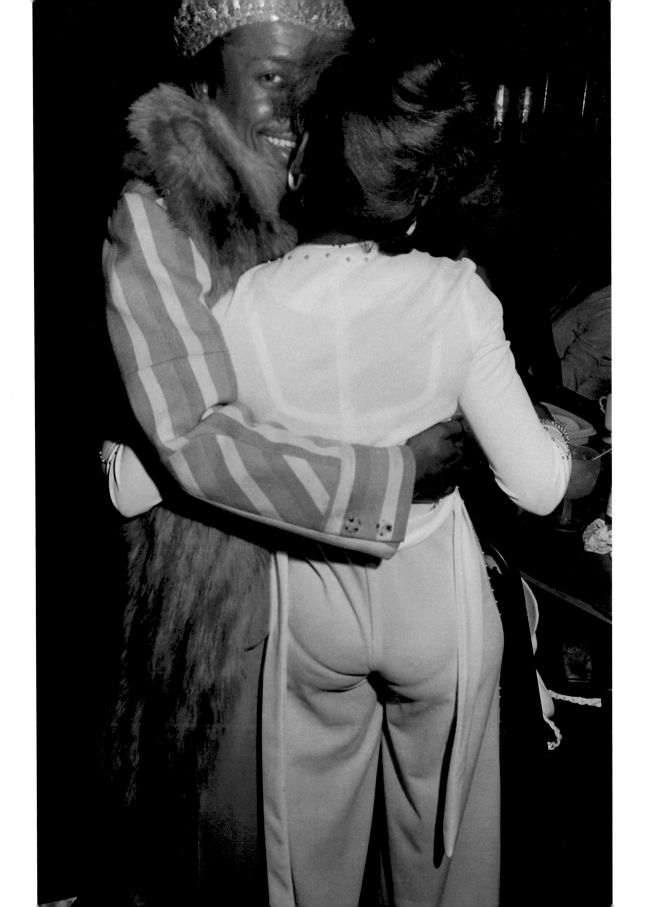

Nothing messes with a player's stride, not even
being one girl's life raft and leap, her last call/
last dance, her sweetgum and rotgut, curfew,
the reason for ripped stockings. I'm her wonder
why, her wandering, her wonderland, her port
and storm, I'm her hold on, her all-the-time
fixed belief in a blue, blue song. Don't nothing
ever mess up a real Chi player's stride, not even
some chile's mouth thinking it knows what it's
doing to the side of my face. That's not a kiss,
it's a prayer. It's a prayer that girl started when
she woke up this morning and saw what she
saw in the mirror—then nighttime came way
too fast. No woman's mouth, especially one
young like this, wide open, pointless, tongue
wondering whether to flick or lap (neither one),
no mouth messes with the slick and slither, my
know-it-all, shine right down to my fingernails,
polished last night by some other little gal who
planted a prayer on my cheek, hoping it would
grow. This one and that one don't know, can't
know, I done already moved past whatever they
think this is, that the gut in the music is 'bout to
push me into the arms of some other fine maybes.
Eyes already fixed on the lips of tomorrow night.

Damn, I'm already looking at *you*.

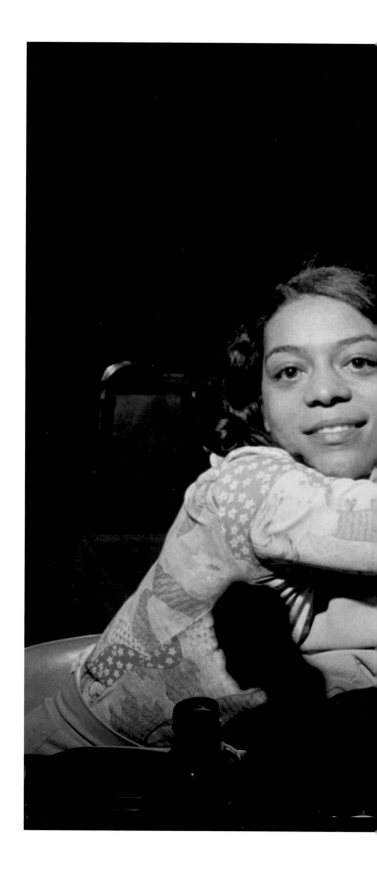

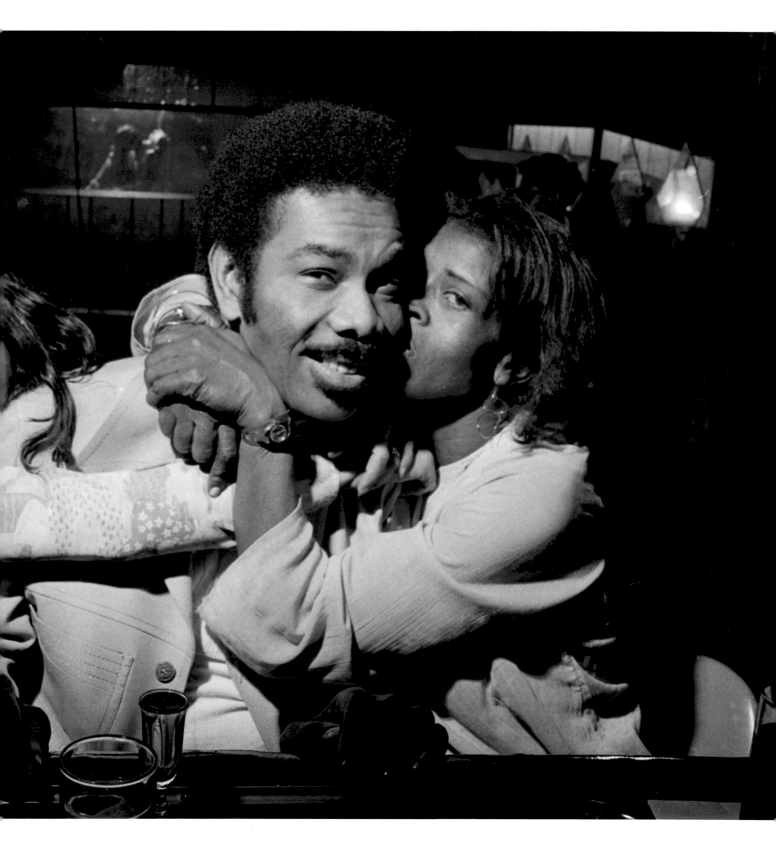

When a woman shows up with her 'fro a halo laying like light on her shoulders and her dress is repeating roses and her right breast strains for air and she's learned just the right way to manage a barstool and she smiles like she knows how inevitable she is and isn't it a mystery how money-*moneymoneymoney* always finds her, how she hefts it and spins around again and again?

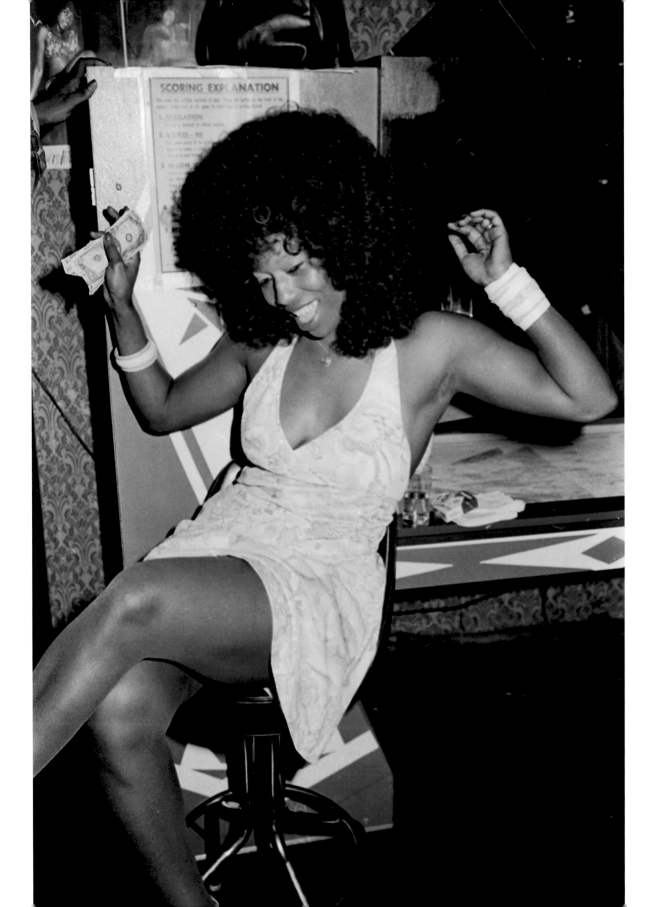

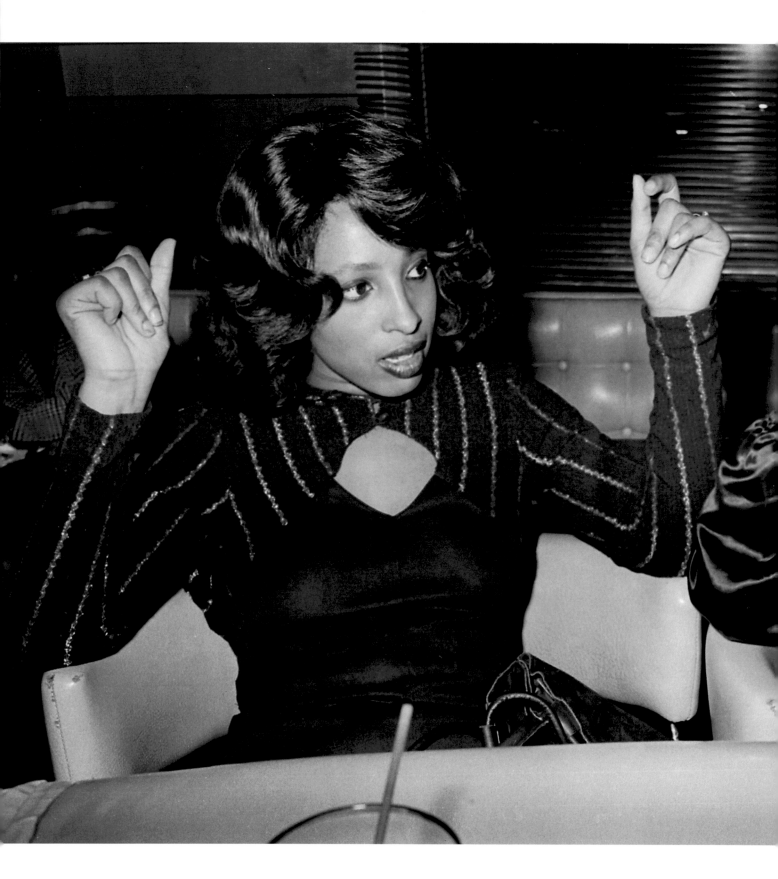

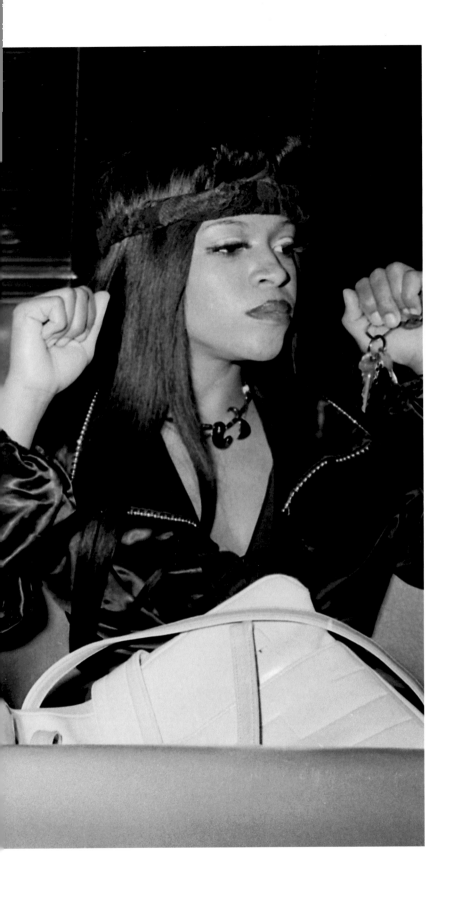

We dance demurely in our seats while waiting for partners. We know we're the best chance in the room. When there's a soul pop in the 45, we just have to pump our fists, not enough to conjure a sweat, but just enough. We're counting under our breath, because coordination counts. Our breasts are hinted at, our hair is paid for, we are pretending surrender. This is your luckiest unlucky night. Consider, rehearse, do not approach. Songs are written about us. We are chorus, bridge, hook. Go on ahead, dance with us. We'll be right here.

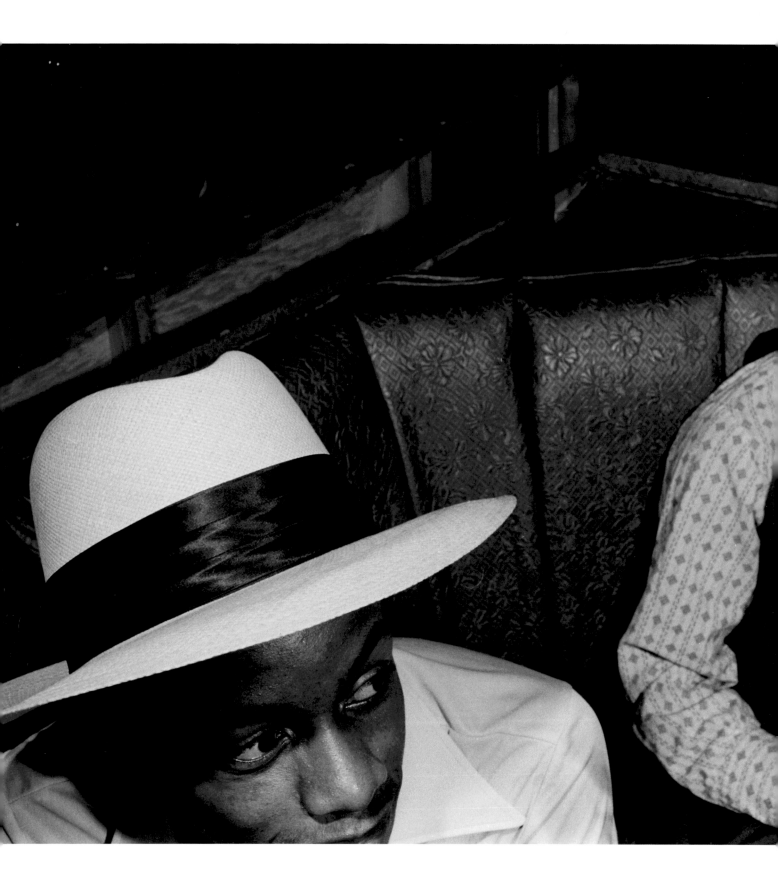

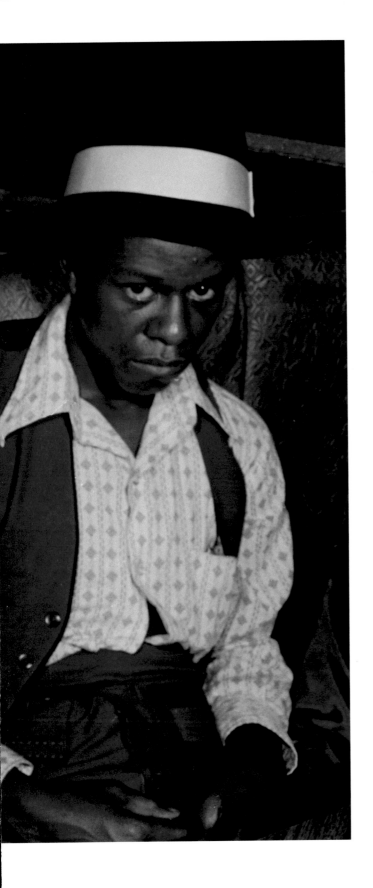

From underneath a wide-brim, not ruling the room
is never an option. This morning, nobody could
remember my name—I was just some man with
no music in my shoes. Now everyone holds their
breath when I bop toward them. From underneath
a wide-brim, I have the power to bless. It's a halo
I can dip, adjust, drop low over one winking eye.

Not everybody comes here for a woman. Some
of us come for a certain blue, for the wicked
skip of that broke-ass jukebox. We don't come
huntin' for luck or a gal with her whole night
twisted in our direction. Sometimes all we want
is what whirls hard the bottom of a shot glass
or the heartbreak song that only costs a dime
and a dime. We're here because our apartments
are too damn hot and it's July and it's Chicago,
we ride in Buicks that look like boats, we come
because the street pushed us in here, right into
the wash of a red light where we prop up bony
and mean and looking like we didn't come here
lookin' for women. All night, we bob our heads
to each other's bad news, brag to everyone that
there are blades shoved deep in our pockets, just
in case. We cuss the air to keep ourselves awake,
wear wide-brims because they're close to crowns.
We glare to keep the world away from our hearts.

He who cannot do, watches.
He who trips over the feet he
was given, who stumbles over
his practiced rap when a woman
is near, simply lowers his eyes
and slips on the mask of weary
player—*done that, done that,*
done that more than once—until
his reputation is sage, elder,
kingmaker. All because he's
terrified by the thought of feet
gliding along floor on a timed
thrust matching a drumbeat,
or a woman with eyes upturned,
waiting. He who cannot do
is thrilled there is this thing
called *cool,* a veil that conjures
mystery—so much mystery
that indecision isn't even an option,
so much that no one comes near.

Then there's
he of the unwavering gaze.
He of the *whassup,* the *what,*
the overwrought shades in
a room that's already dark.
How much of him hides
behind there? How many
questions has he decided
not to ask, because, because—
well, does it matter? Best
to be beautiful in a way
that invites no discussion.
Best to be hard and fragrant,
to favor a fabric that clings,
to stare, unflinching, until
someone digs up the nerve
to stare back.

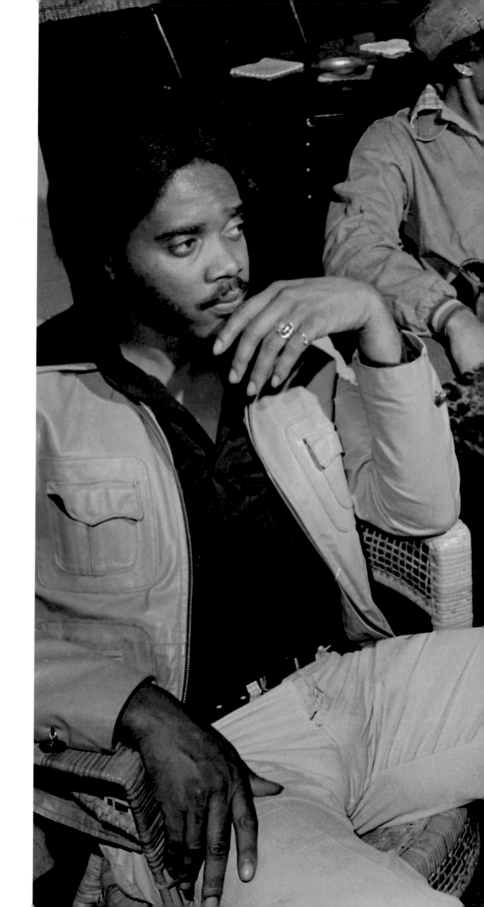

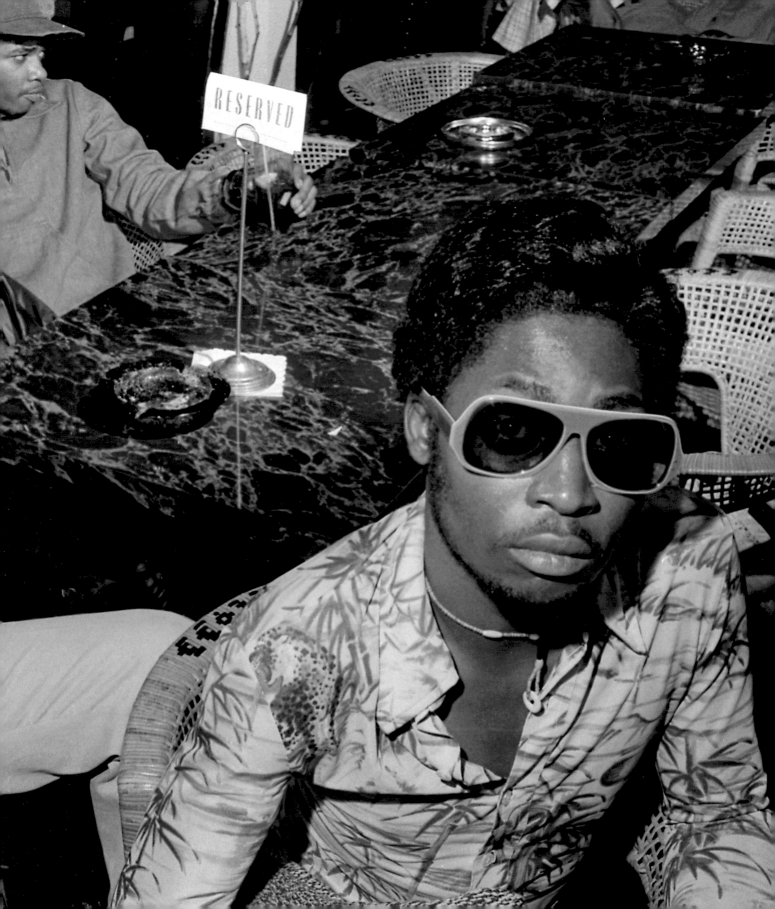

RESERVED

The befurred warrior, guardian of the handbag,
surveys his kingdom in a manly way, hoping
the toothpick and lean hide his irritation as his
woman dances without him. If he'd worn a shirt,
if he'd only worn a shirt, he wouldn't radiate such
heat, and a slice of the floor could be his. Instead,
he is becoming a smell, a tangle of funk and envy,
not believing that woman just had the nerve to say,
Watch this, baby. Imma be back. I'm fixta dance!

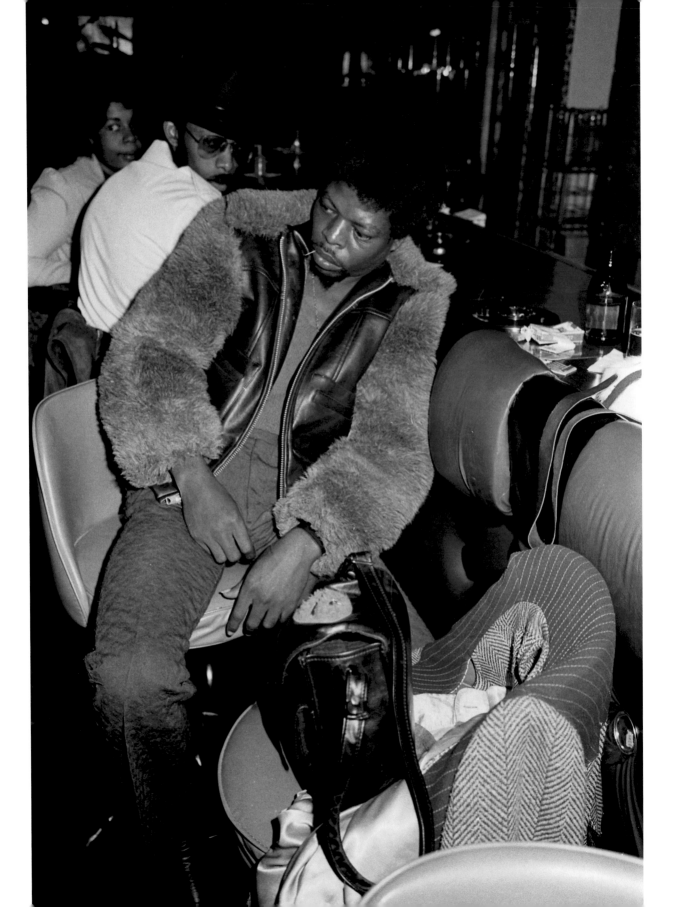

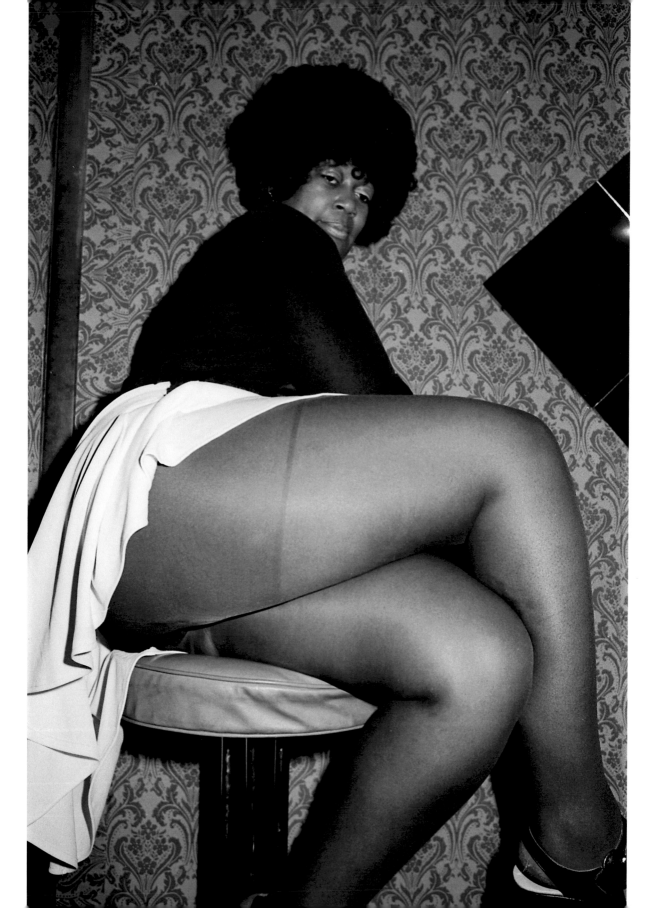

Not even making a move to hide all
this. Not even going to pretend that
it's not what I was counting on when
I came through the door, that this skirt
wasn't born to ride up until it stops
being a skirt at all. This is desperation
born of detail. I am a story you can't
unsee. I am a whole corner of this damn
club, a roaring proposition, and you—
well, you have a decision to make.

Sweet Funky Mingle of the He and She

What you can't see is that he is whispering
indigo in my ear. He is promising promises
with edges like blades, he is calling me
beautiful over and over. If there is a song,
something blue beneath the needle, I can't
hear it. I'm dancing to a slow-twanging guitar
of *almosts* and *maybes,* craving the shrinking
inch between his tongue and my throat. I pull
him in so tight the two of us share an air,
an air hurtful sweet with our tangling. I sigh,
and beg my whole shivering body to say *yes.*

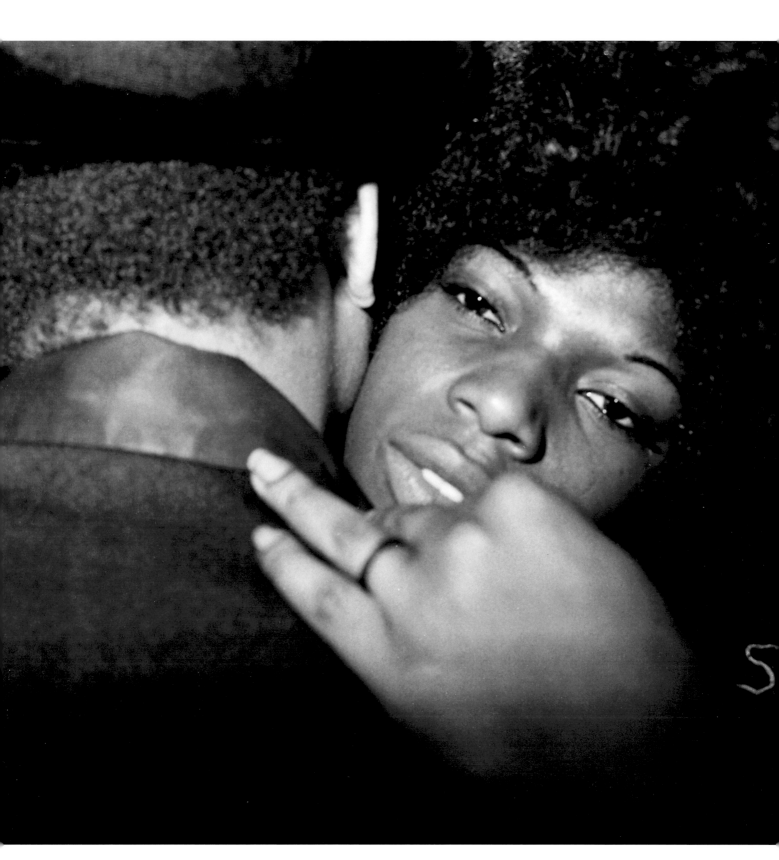

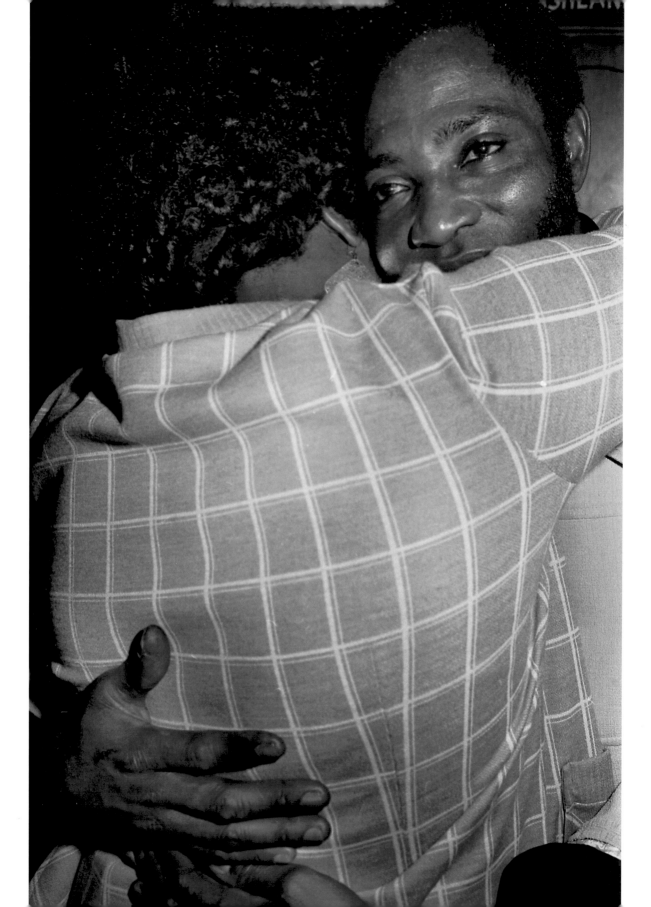

You can see a lot in the way a man
holds a woman. She is a momentary
distraction, or she is a lifeline. She
is the first woman of the night, or
she is the last. She is revelation
or salvation. Maybe she is long
in coming. Maybe she is a word he
will say in his sleep. Maybe she
is the reason he will sleep through
the night. Maybe she is the morning.

I'll tell you if you tell me
If you tell me, I'll let you know
I'll whisper it if you lean in
If you come close I'll tell you
Tell me, and I'll come close
If you don't have a secret
make one up
We can't leave here
Unless we've crossed a line
Given something that hasn't been
given to anyone else
Tell me
Whisper to me
Come close
Make one up
Make us up
Whisper me
Cross the line

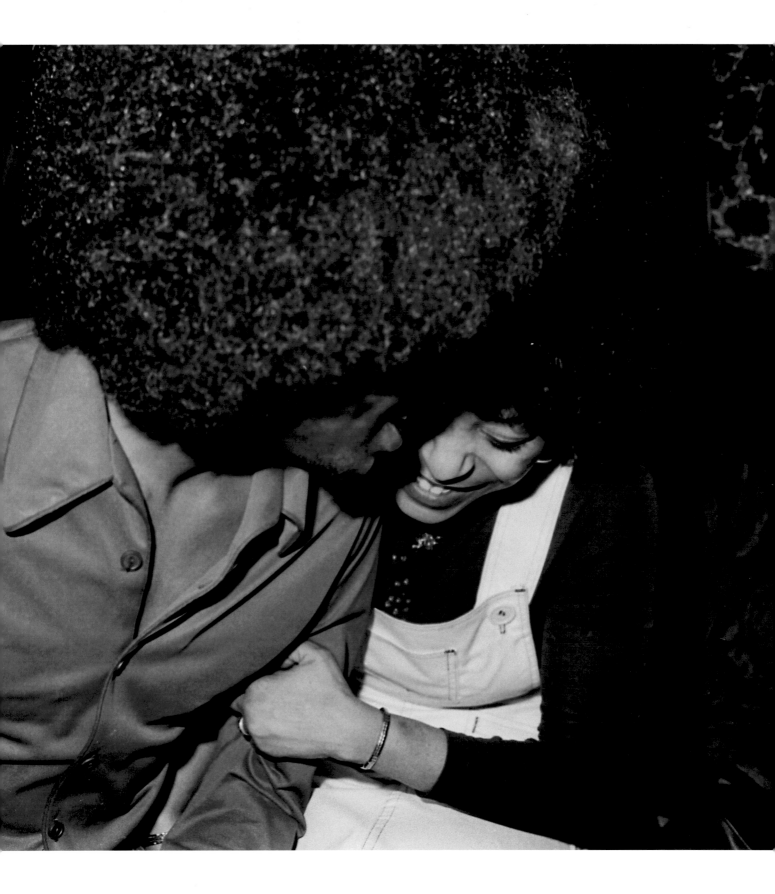

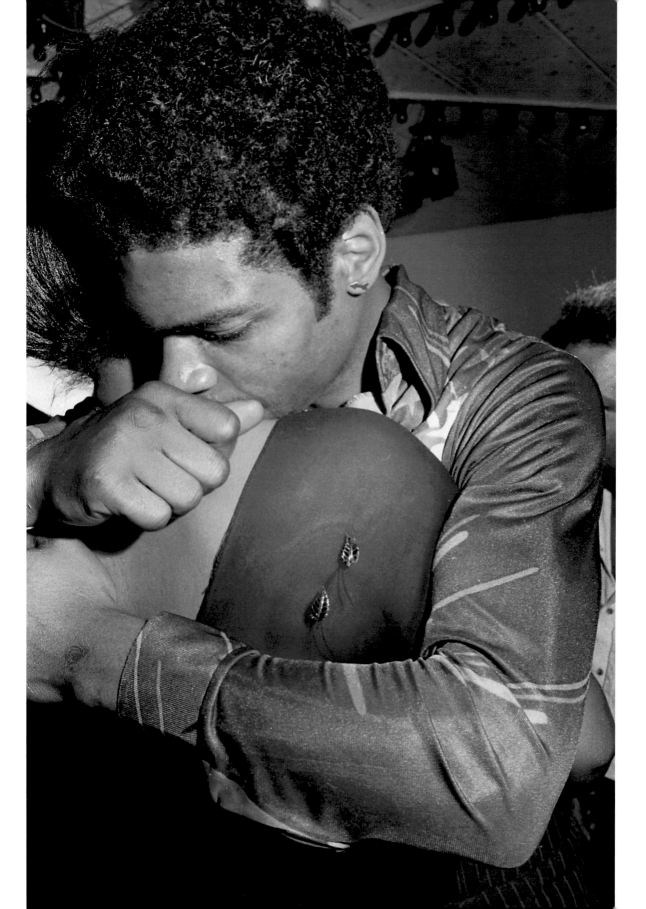

If you look closely, you will see his
millisecond of surrender, his shield
down, a tamed ache behind his eyes.
You will see his muscle give in,
his frightening collapse into a woman.
Usually, the weakness is heralded
by a sour pluck on a guitar, a note
that reminds him of a time he could
have wailed. The woman feels a fleeting
twinge of pressure, a heaviness on her

shoulder, and she thinks, *He needs,*
but then, with a sharp intake of breath,
he is his own someone else again.
The song winds down with a dimming
heartcrack chorus and he pulls away.
Everything, everything is muscle again.

Not at all wooed by the abstract art,
the smarmy blurb for Pimp Oil,
or the *I got this* leer of this man
who most certainly
does not have this,
she has decided to, once again,
be her own art.
Her symmetry is frightening.
Her hair is spritzed and sprayed
against droop, and its graduated gilt
squeals softly
under the blare of the club lights.
The teeny scarf, bowed and bowed again,
seems to grow demurely from her neck.
And the gentle east/west of her chest—
well, as long as she doesn't move,
as long as she doesn't spoil
the still life of herself
by lifting that cigarette to her lips,
glory be this night.
Ain't no woman like a Chi-town woman.
Everywhere she be there be art.

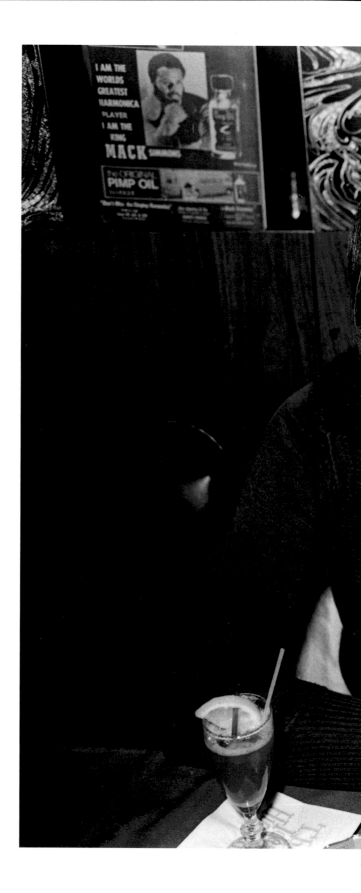

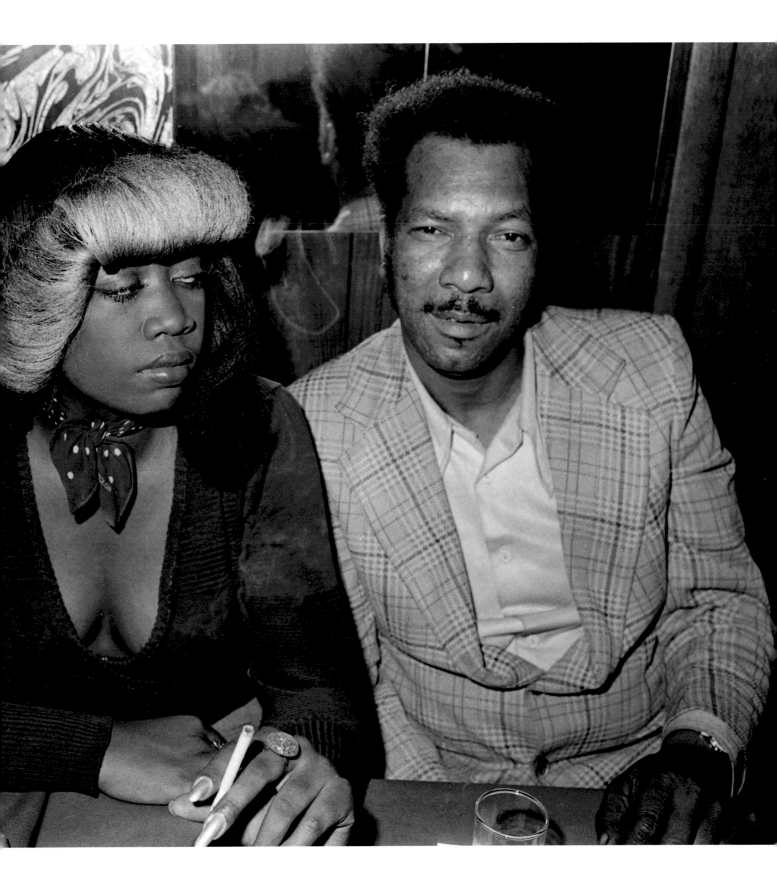

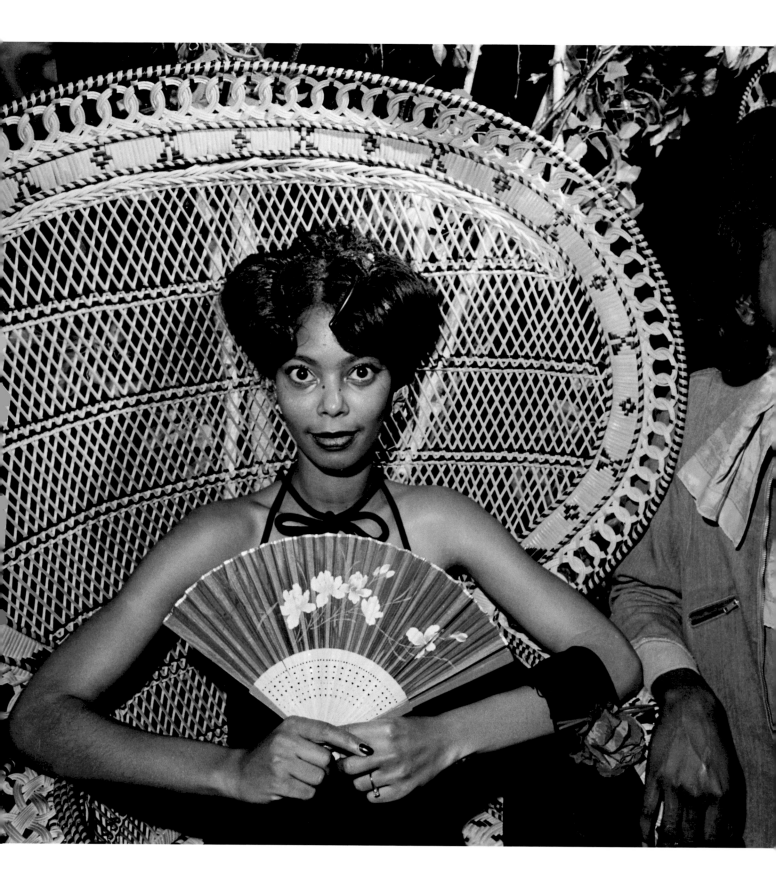

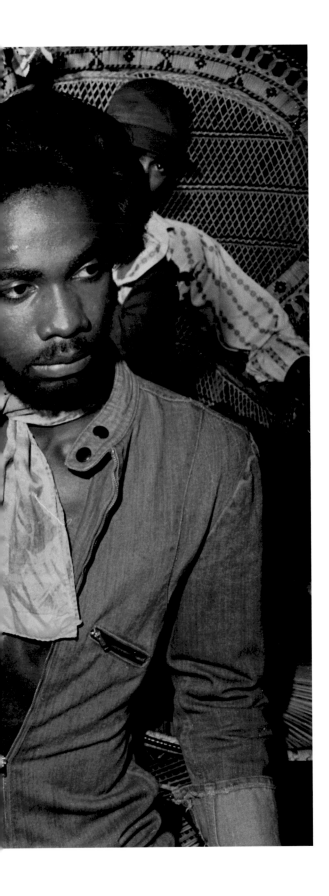

I imagine I never did have to be from someplace this cold, someplace where everywhere I'm allowed to go looks like me. There's a sweet place in my head where being brown is a birthday, where I can add gorgeous syllables to my name. Whenever I walk into a room of smoke and pivot, I search for the woven throne, slip on the cloak of queen—because tonight is not about the juke or the joy-sweat slicking the dance floor—it's about what brings out men who are mad for no reason, men who can't look straight at what they most need. It could be heartbreak—the thrusted fist of Chicago with backslap winters and jobs born to break the back. He goes through motions, pouts in a queen's shadow, and sets his face in a particular stone, hard under that difficult hair. Neither one of us knows what the night holds for us. So instead he holds the night. He stands stiff as it struggles in his fist, he won't let it breathe.

When a woman puts a feather in her hat,
she means business. Some say it's a voodoo
thing, say she's giving herself a wing.
Some folks say she's sporting
a little bit of church on her head.
Either way, the man doesn't know
he's doomed, he doesn't see the demon
lazing behind her side-eye, doesn't realize
how long ago control was lost. He can't
see the claw sprouting beneath the table.

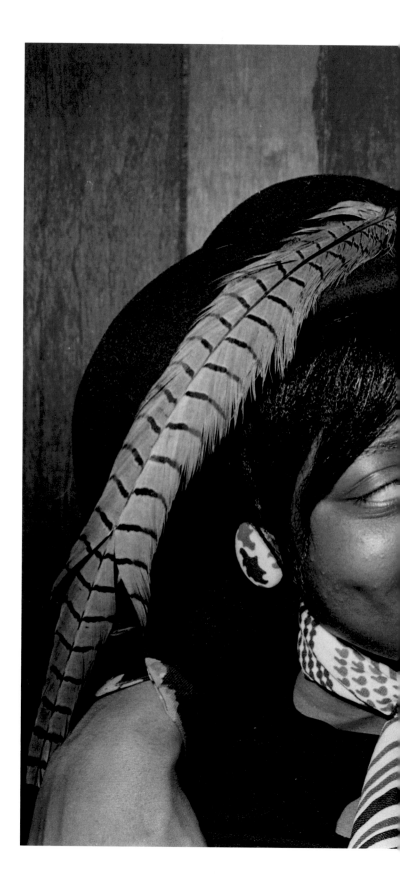

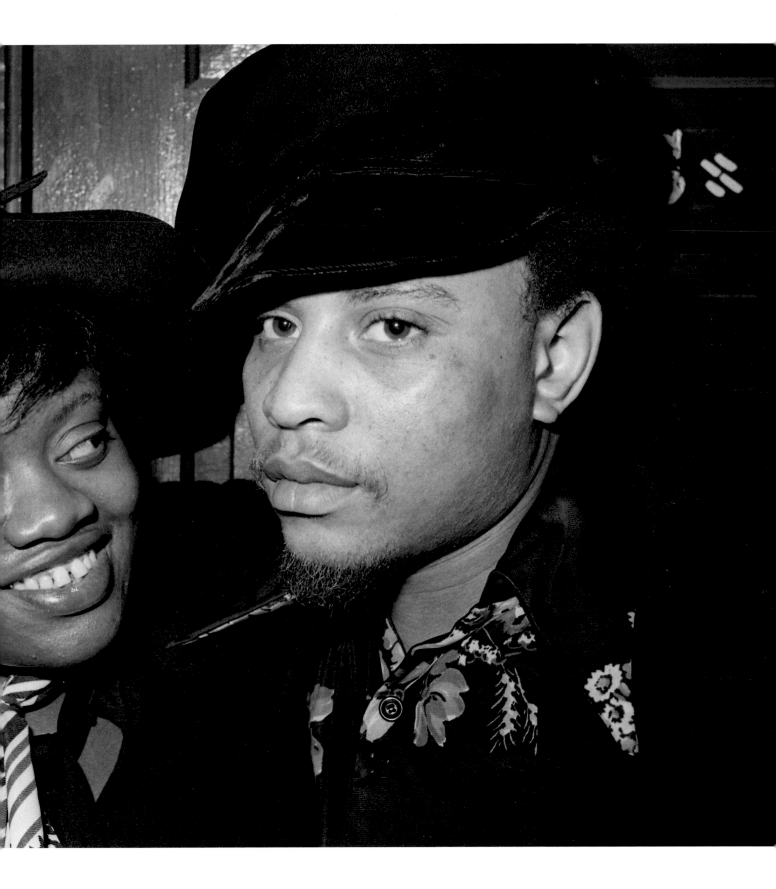

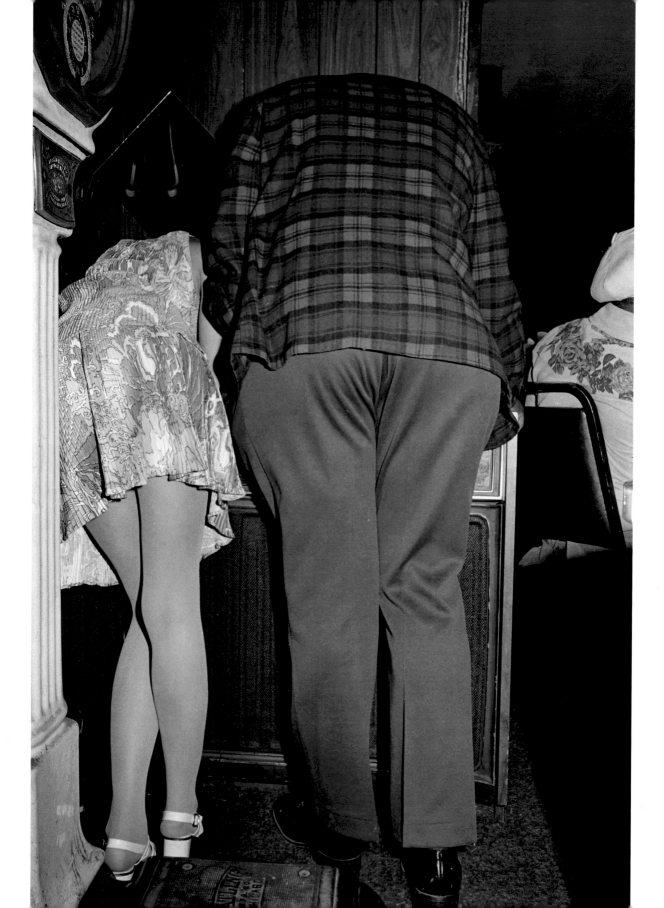

The room is full of secrets like
this. Secrets you have to bend
over to conceal, secrets that worked
their way in from Chicago boulevards,
secrets that have a smell like smoke.
Nobody needs to see what song
we need to hear, what song is about
to fill the room, what heartbreak is
on tap today. Just let the hurt surprise
you. Let it hurt for just long enough,
then get up and dance.

Girls on the Verge

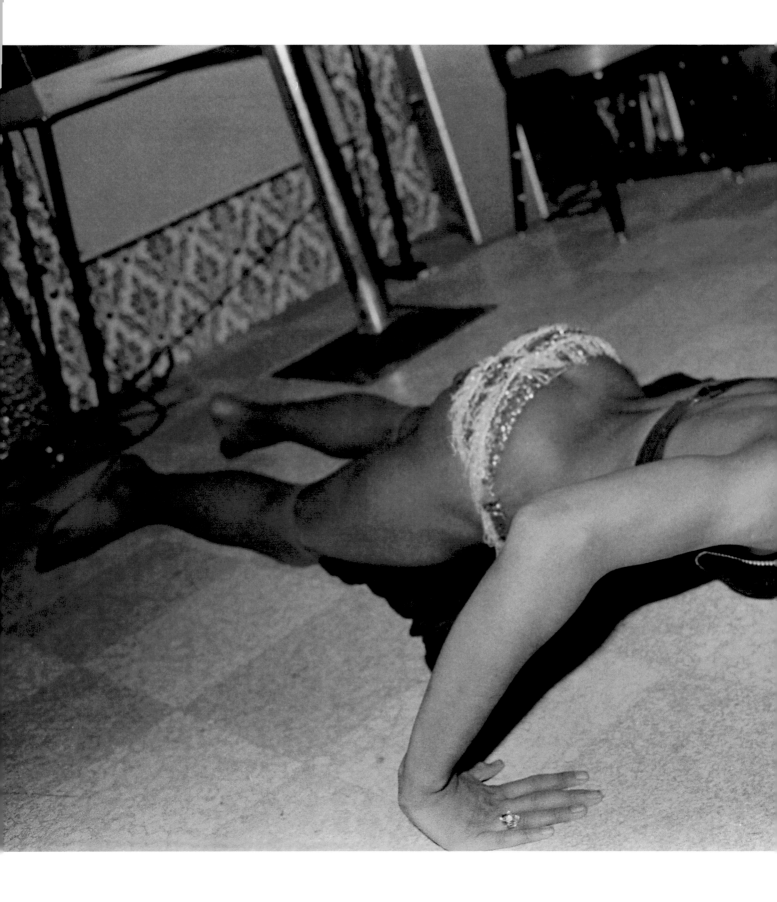

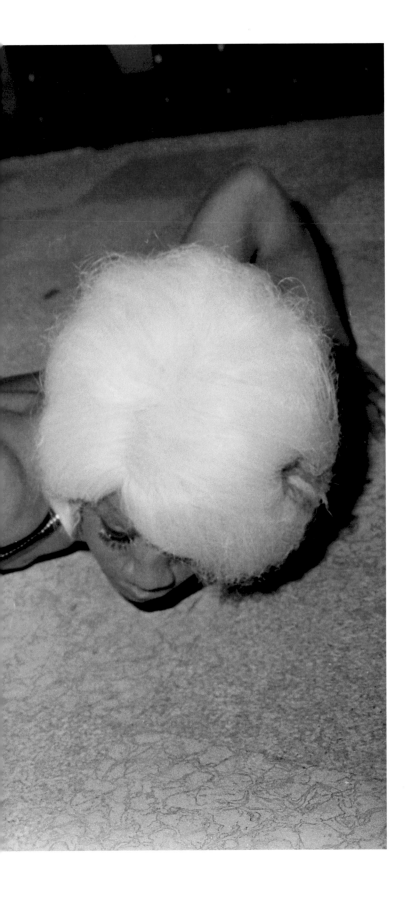

Only a fool would call this dance.
This is a roll call of what the body
can do, it is muscle and the holding
of breath. This is what a dress prevents.
This is hair overdone and bursting gold
as if it makes a difference. Music has
no place here. This is just panting
and sad acrobatics. It's the unrivaled
stench of the floor. If not for the pout
of a sequined butt, there would be no
reason. Let's say she loves Chicago.
Let's suppose her name is Ruby. Let's
suppose that was her mother's favorite
name, but let's not think about that now.

I come to play, to stretch my body
across the table, to make the men
rethink me as a threat and not an
option. I come to play, to flash muscle
and to curse when I need to, I come
to be pretty and threatening, to run
the table, to win and grin wide like
it was all a surprise to me. (It wasn't.)

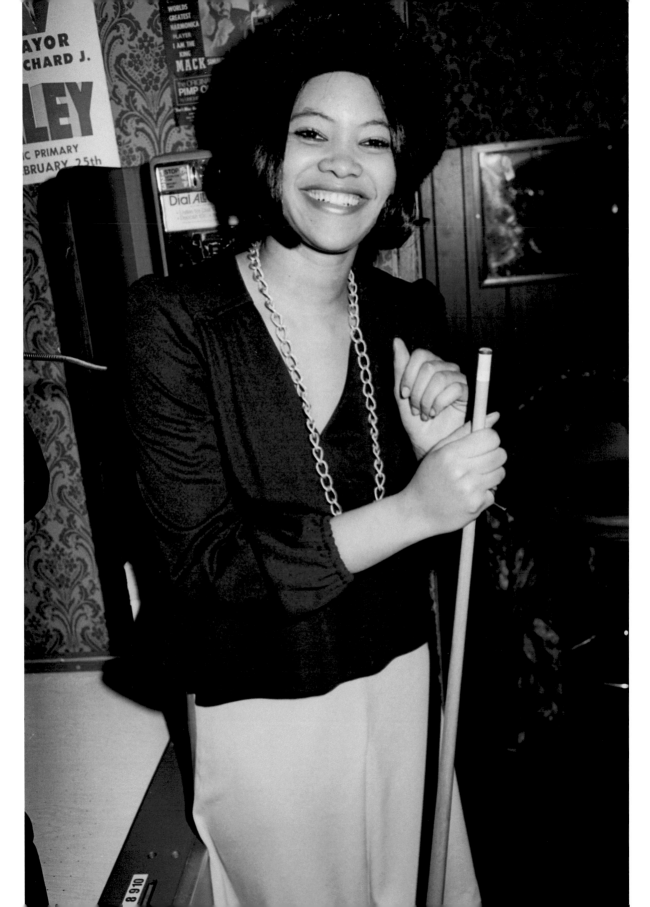

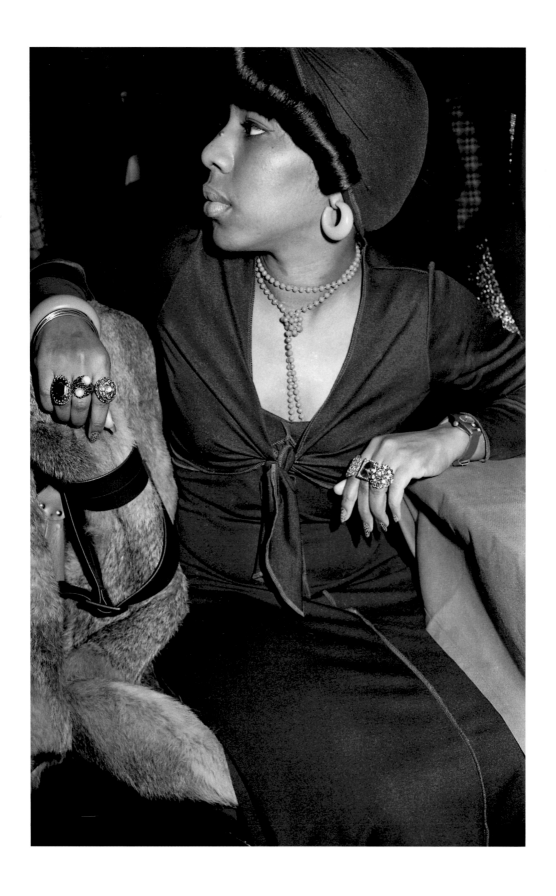

It's in the elegant swoop of the nose, the lips blooming full, the persuaded gaze. It's in the gleam winking from fingers, the assured drip of beads, the way the body drapes across the fur of a beast. This may be the High Chaparral, there may be a Chicago winter waiting outside, ready to beckon and bite. But everything about her speaks Africa out loud. Everything about her says *Remember.*

You can't fight
the 'fro, the explosive
tender of it, the curl
and kink, the light
shining from inside it,
you can't argue
with its million fists
raised high in the air,
its depths, the way it
claims its own heaven
Once it is in the club
it is a beacon
Men want to plunge their
hands into its kinky waters

And look how
she knows
and she knows.

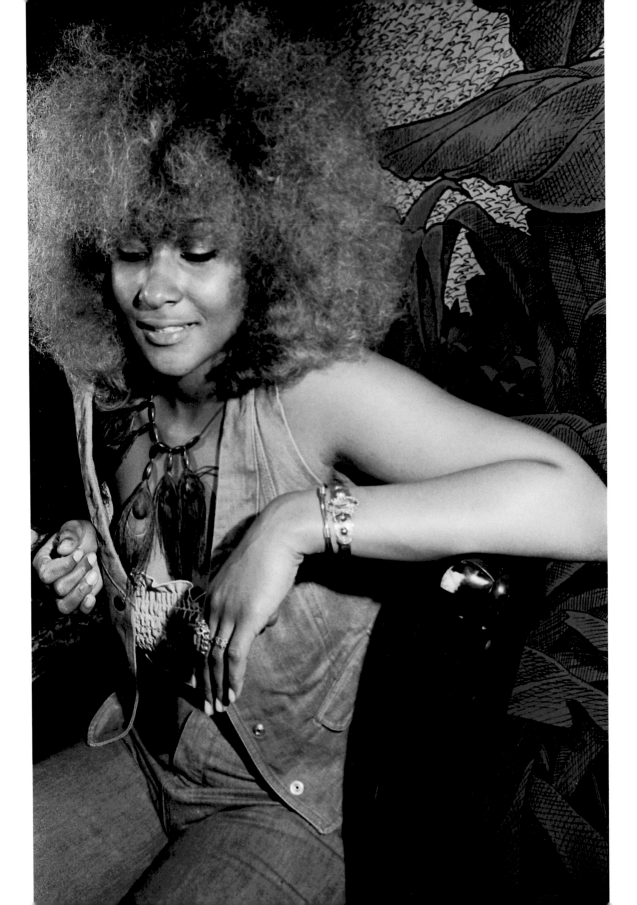

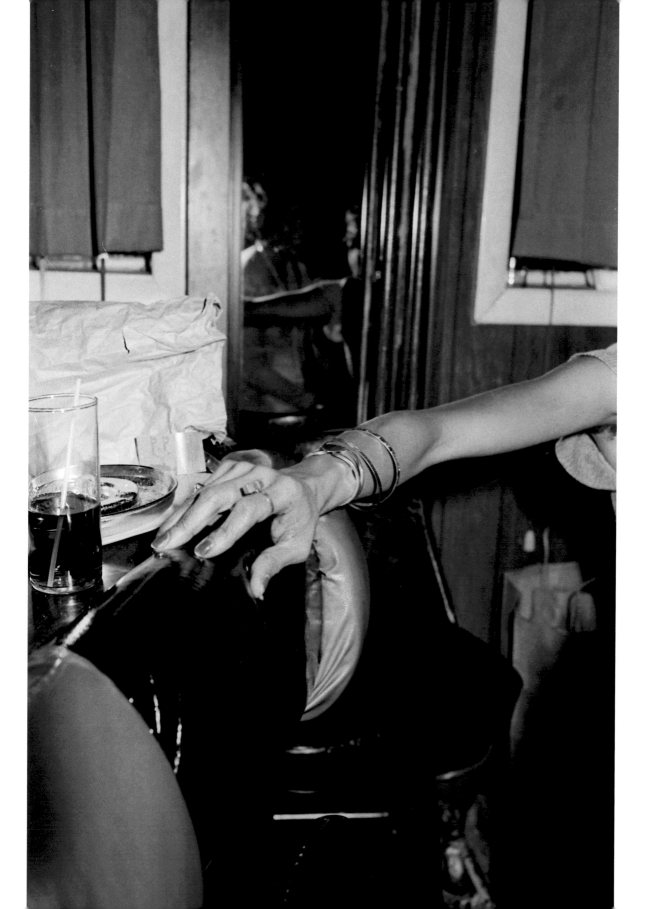

Cream-smooth and manicured, but showing
its age, an old wariness that creeps into
the bones of the fingers.
There is a type of time that's terrible
at hiding its face.
But a glass of sweet lightning should
always be within reach,
should always be just about half full,
should always, always be ready.
It whittles the night down to a moment
that can easily be managed. It helps
a woman lose track of how many times
she's done this, done this, done this.

When I am ready, I shall reveal.
When I think you're ready, I shall reveal
this—this heart I've nurtured, this
work I've done, this breathless, this
dollop of brown magic, this bomb, this
way out of no way. When you are ready, this
will point the way to your whole night, this
woman, and all my little mysteries will be
all you want.

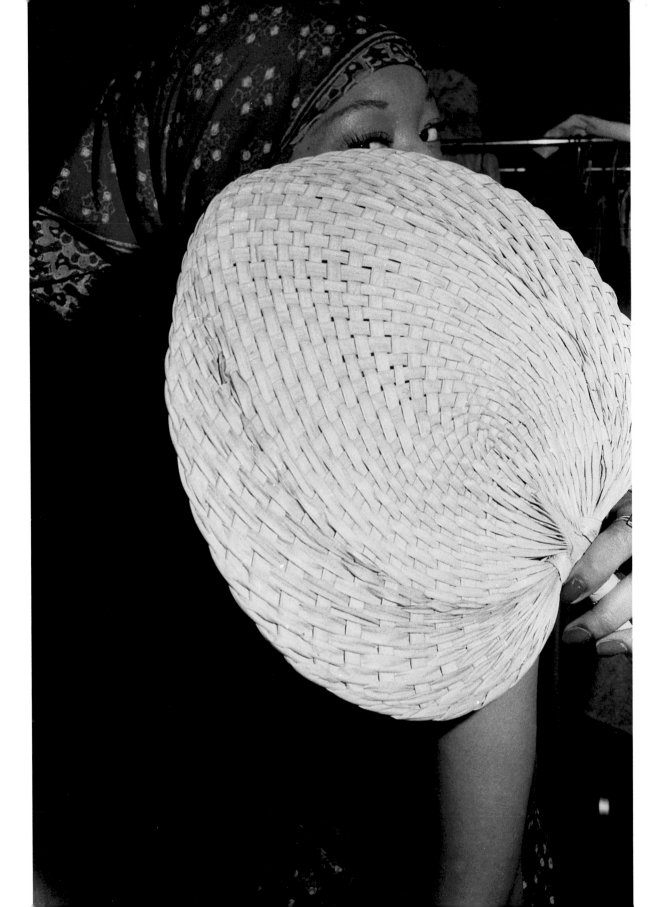

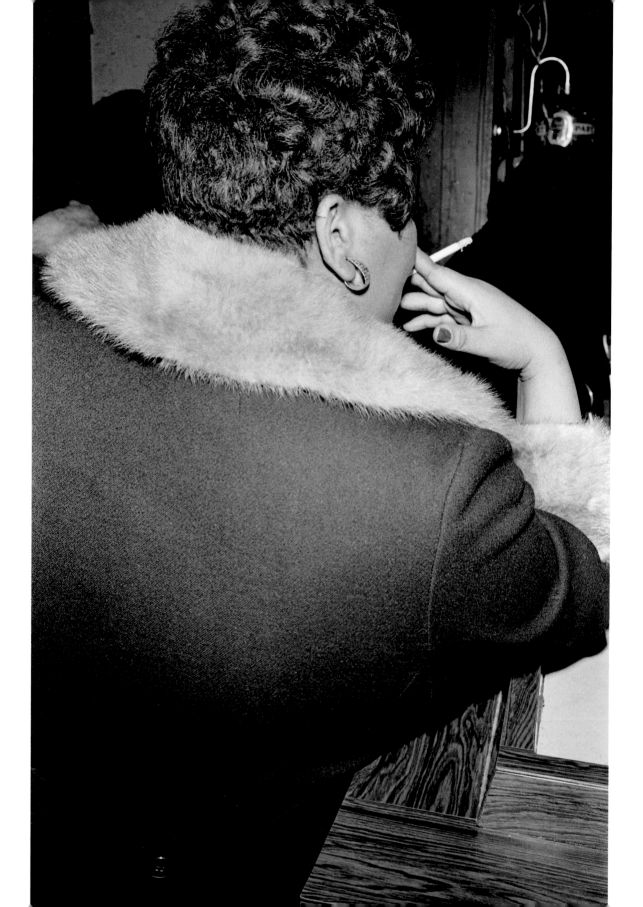

I am not about
compromise
I am not about
negotiation
I am not about
discussion
I am about
this stick
this drag
this overview
this decision
this whether
or not
I will consider
compromise

If there is no hell, no heaven, no blue-eyed Soul Man shaking
His head at everything I do, then I'm crazy all by myself.
That means I can collapse any-damn-where I please and wait
for the smudgy fingers and busy tongues of curious strangers.
I can deny that organ wail and all those Sunday-driven vows
I made and gleefully lie down with whatever comes near me,
then pull myself up with every sin wiped clean. I could peel
away what hampers me and scream all I want out loud, I could
prop my breasts upon my belly, I could dance the way I want
to, all engine and bleeding battery. Happy fools just love teasing
damnation, all the time flirting with the idea of a line that should
never be crossed. God, if you are not now, when were you ever?
What I need is a roadmap, a bonecracking nudge to the side of
my head, a swift kick to the buttside. I need Mahalia to sing
to me just like she used to, hands clasped and watery eyes
lifted up, but when it all comes down to it, though, ain't she
just another woman waiting to be saved by yet another man?

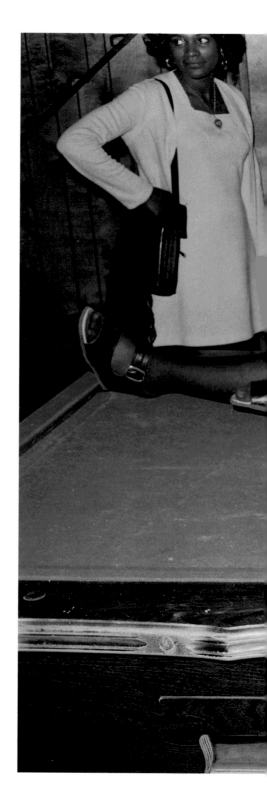

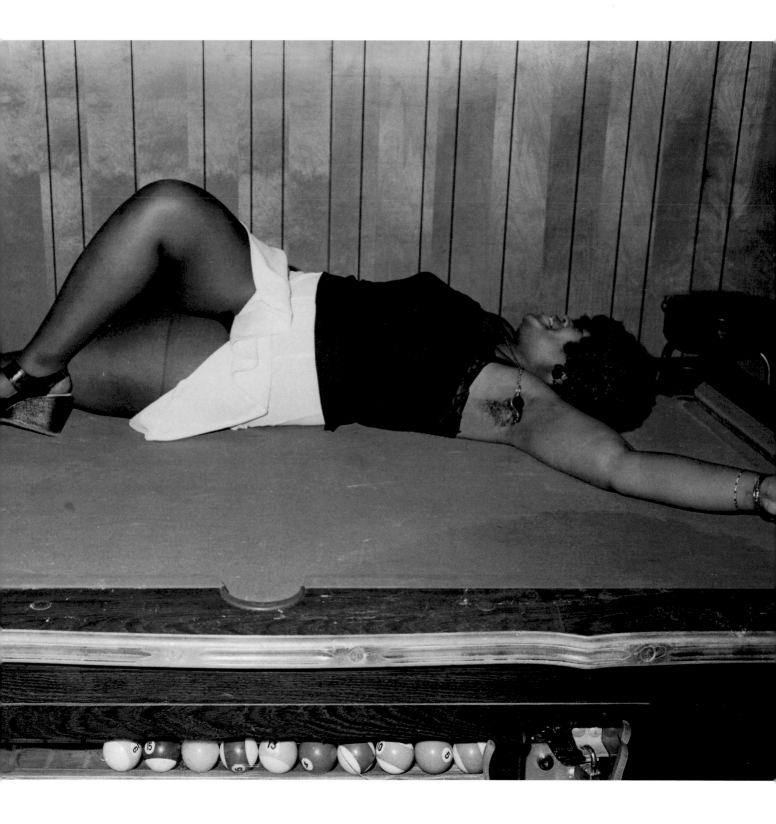

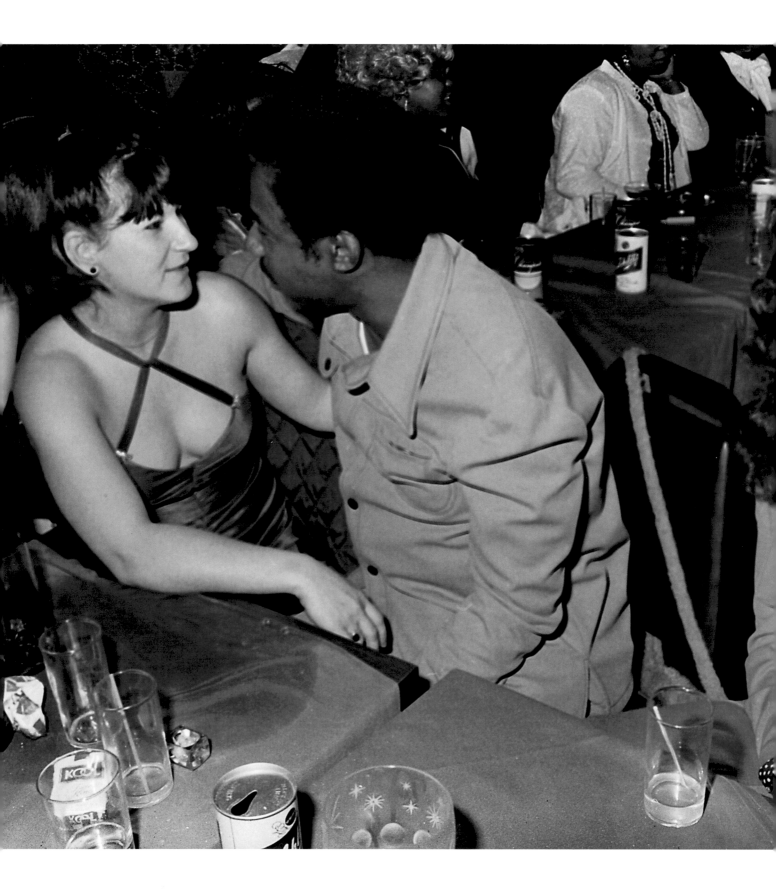

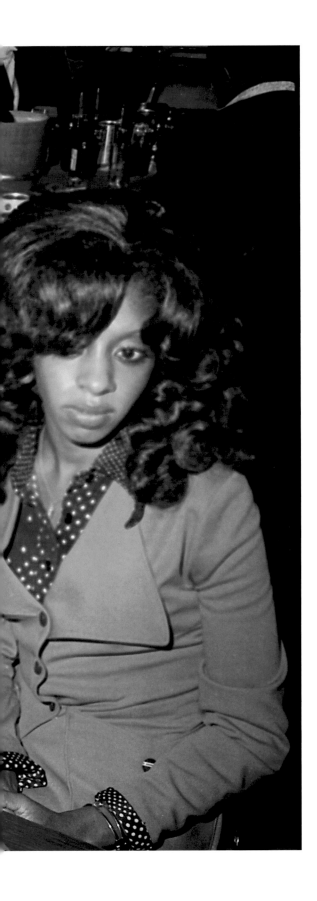

little girl lost
little girl wondering
how much heat
she can absorb
in this wondering room
that is fascinated and appalled
by her
and he
drawn in
to the wonders of this other
country
that can only be possible
within the confines
of this night
what are they drinking
what are they thinking
this is chicago
this is america. oh wait
this is
1 in the morning

so the only question
(while the brown girl pretends
otherwise)
is

how much heat

Wide-Brims and Hard Hearts

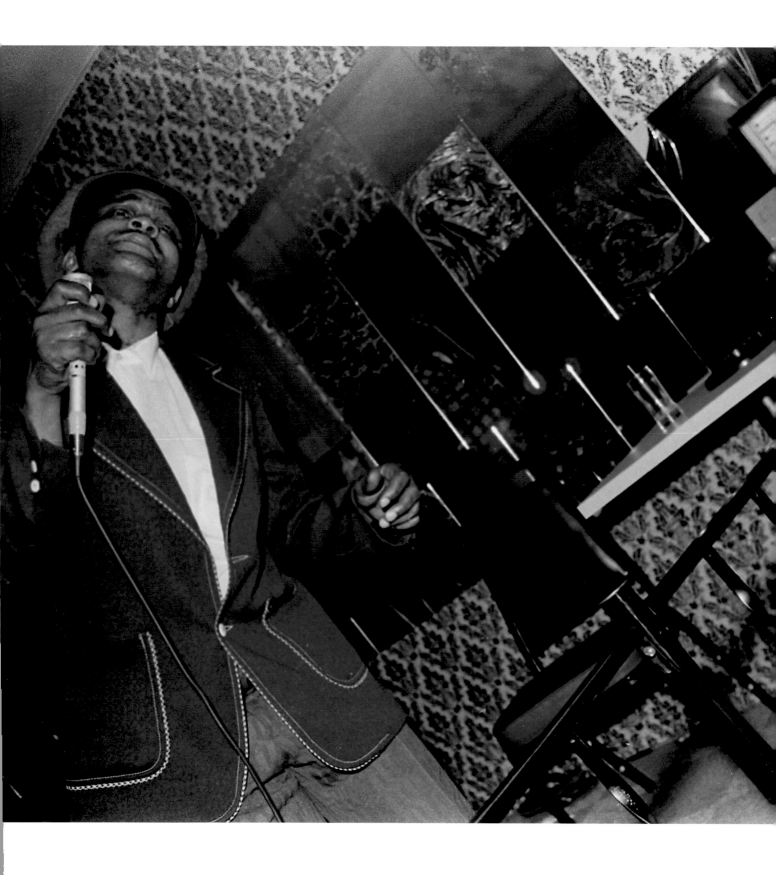

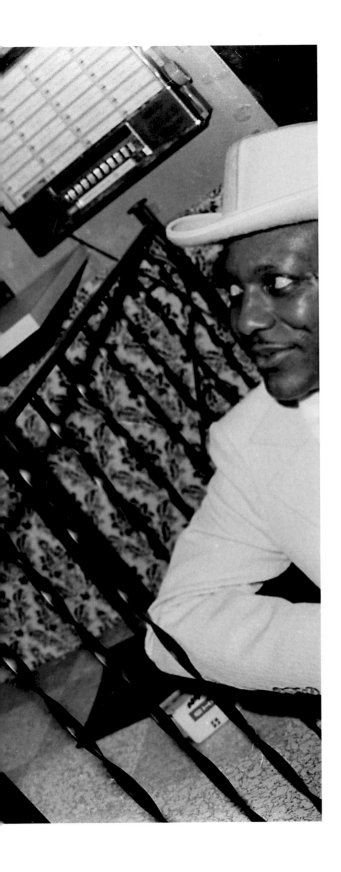

The man who cannot sing wishes he could sing.
The man who can sing wishes he didn't have to.
The jukebox holds tight to its blue songs.
It is early in the night—the jacket is still buttoned,
no nerves are evident, the white suit is pristine.
No soul has been released.
Perhaps the song is about a woman—it's always
about a woman—and the man who can't sing wishes
the song was over. He has women to attend to.
The man who can sing will sing all night. Soon he
will pop loose that button and his songs
will sound like the prelude to a cry.
He won't let the jukebox take over.
Tonight he's going to make somebody listen.

The definition of *mack:* not afraid of anything
Chicago throws out. Mouth all the time open,
achin' to slice a man down or lift a woman up.
Definitely ready for royal. Hat high enough to
have a couple of crowns beneath it. *Mackin'*
is the work a real man is born to, the walk that
gives the back alleys their song. *Mack daddy*
is what a woman can't help but moan when
she's scared the night's gonna end, when she
thinks his glow might walk away. She lurches
for the stench of spice, the undisputed dazzle
of fur. What *mack* means to the club tonight:
fierce lean, his every inch on the verge of
something that might be wrong. Tonight he
is all about the business of being undefined.

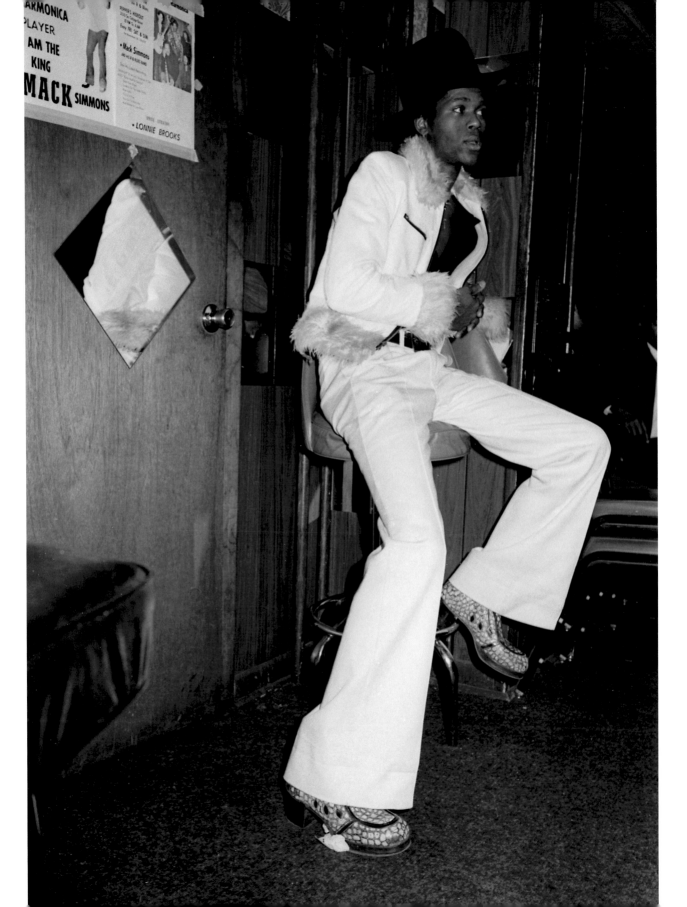

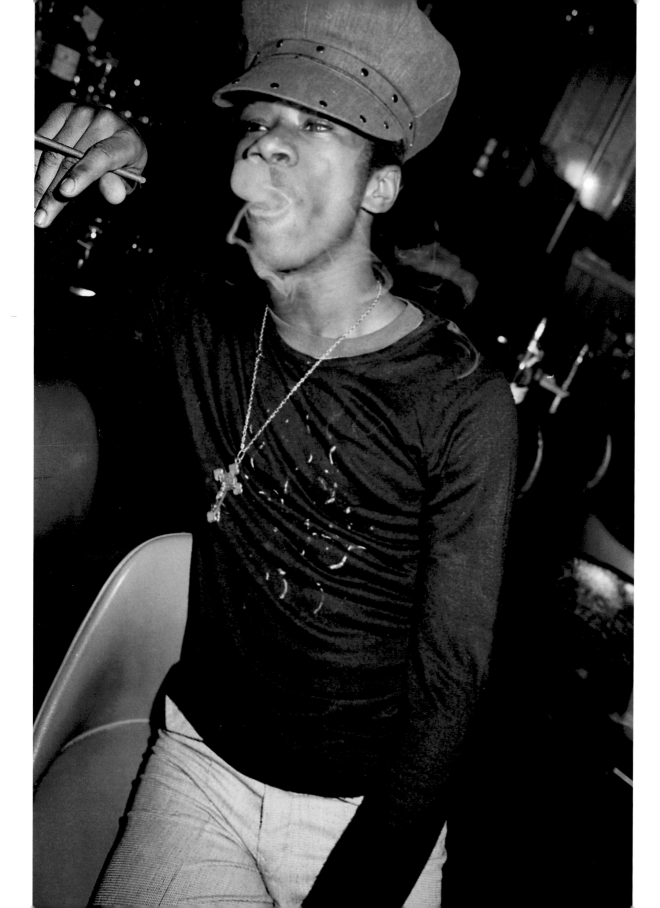

He smokes a long brown cigarette, which
is both otherworldly and sexy. He conjures
a ring of it with the ring of his mouth. His hat
contains multitudes, Jesus dangles from his
neck. Trying not to be ordinary, his nostrils
flared with effort, he blows out art, sucks in art.
To survive in the club, you must be something
no one else can be, do something no one else
can do. He's learned to burn from inside.

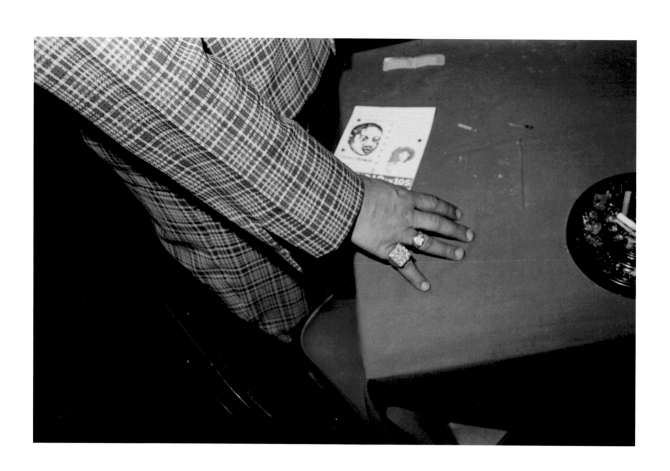

Something's got to shimmer on a man.
Something's got to tell the world that he
has the right to be his own shining sun,
and that havin' money, or not havin' it,
ain't allowed to get in the way. So it's
been in layaway for two years, or maybe
a sugar gal gave up some hard-earned
to treat me to glitter—all that matters
is that pinkie on my right hand, doing
every bit of my hypnotizing for me.
It's paid for, so it's all the rap I need.
Something always got to shine on a man.
Baby, I'm so bright, I'll drive you blind.
Just say the word. I can shine all night long.
I can be the sun waking you up tomorrow.

Our daddies teach us

swagger and tilt
but

can't teach us to

pull back on

the out-loud, slap-happy grinning

of boys with nothing but

tomorrows ahead and behind

us nothing but

the runaway cool of our daddies

as shield and costume

we stay happy pretending

 to already be

what we are already destined

to become

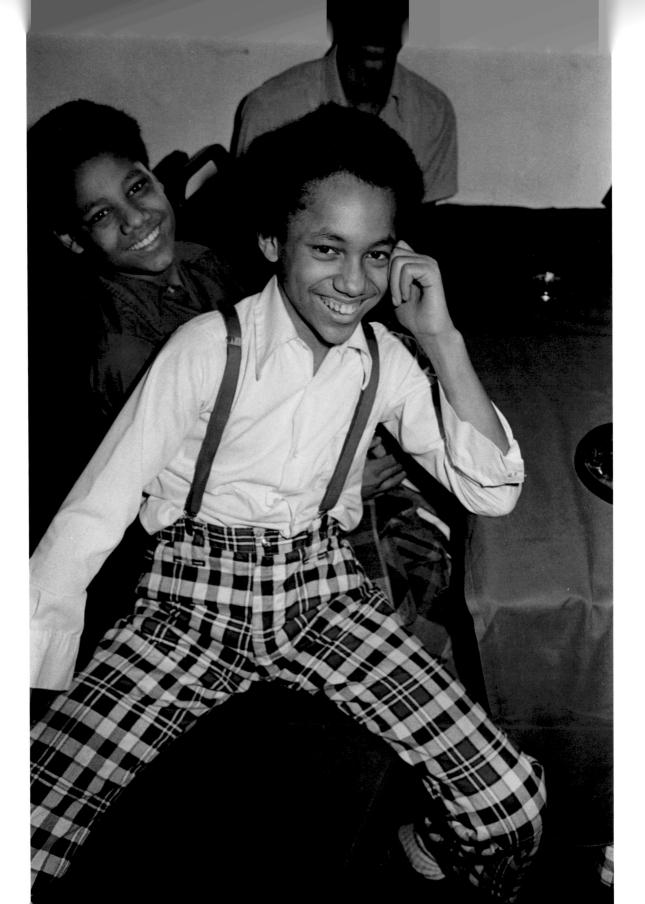

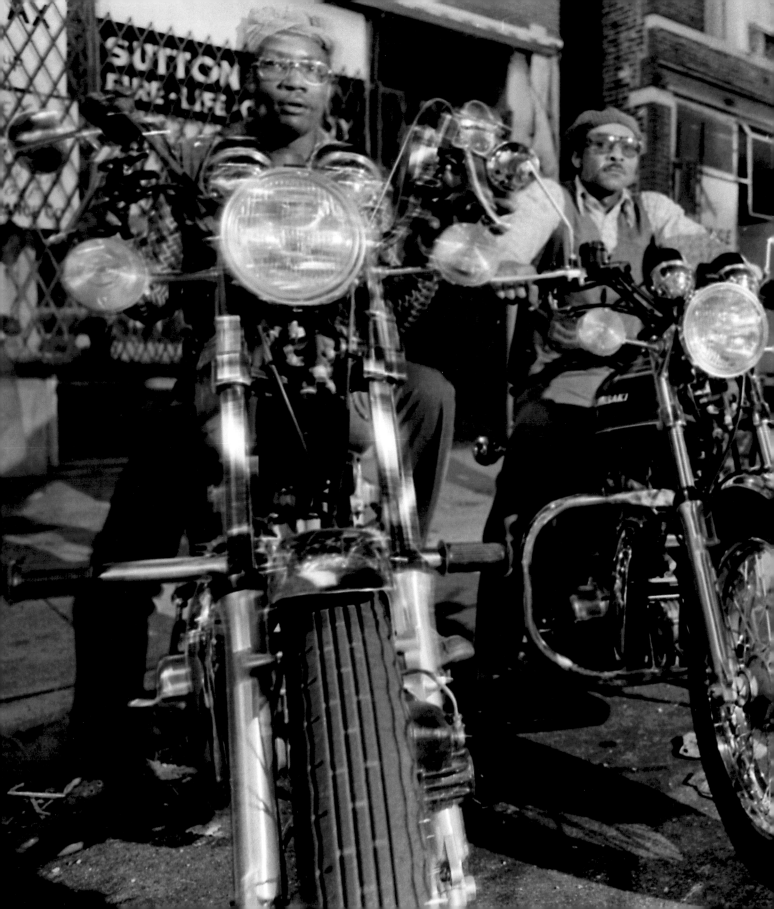

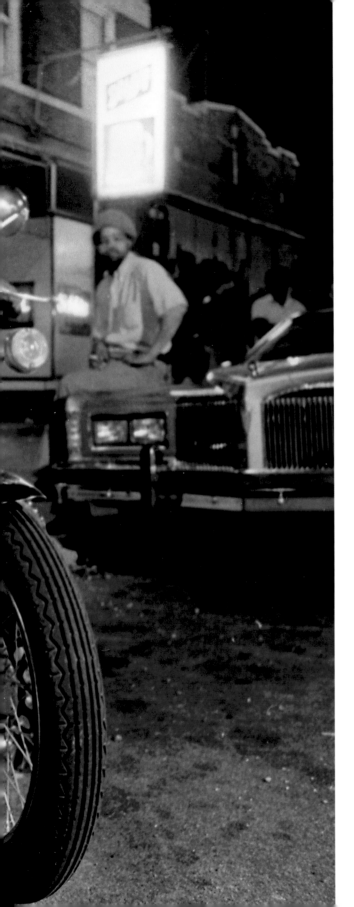

We are the toughness. We are the rough riders, roaring up alongside the club and just revving there until we're noticed. We're much stronger out here than we'll be in there without firepower between our legs. We're the spit of exhaust, the idea women have of leaving with their arms wrapped around us and the roar zooming through their bodies. We're not Cadillacs. We're so much dirtier than that. Every street we ride is foreplay.

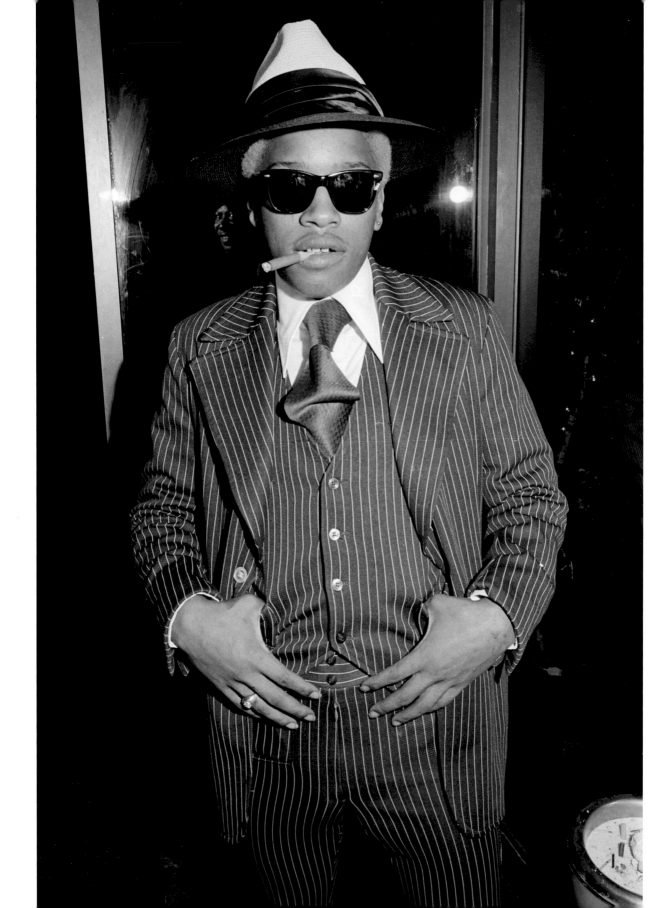

Laugh if you want to. This man is prepared
for anything. Stuffed into stripes that wiggle
and waver, he is brimmed and blond, chewing
on the business end of a stomachache, and
what woman waits for this? What woman
wants this much of anything, an answer for
every damn question tonight might ask?
Smirk if you want—he'll see your giddy
reflection in the mirror and slice your throat
with a sharp word he's been saving up.
This is the end of childhood, the beginning
of man. This is what a child thinks a man is.

How much of me will be lost when
I take off this coat? How much king
will I lose when my tilted fur crown
is removed, when the heat gets to be
too much and I'm down to just my shirt
and pants, how much royal will I lose,
how many women will turn away once
they see how ordinary my underneath is?
When my raiment is gone, so is my sneer,
my undisputed rule, my power to hypnotize.
What will I do when I am just a shell with
my muscle resting on the back of a chair?
I would rather burn all night until I pass
out from the trumpeting temperature.
This second body is all the body I have.
I'm frightened of the body beneath.

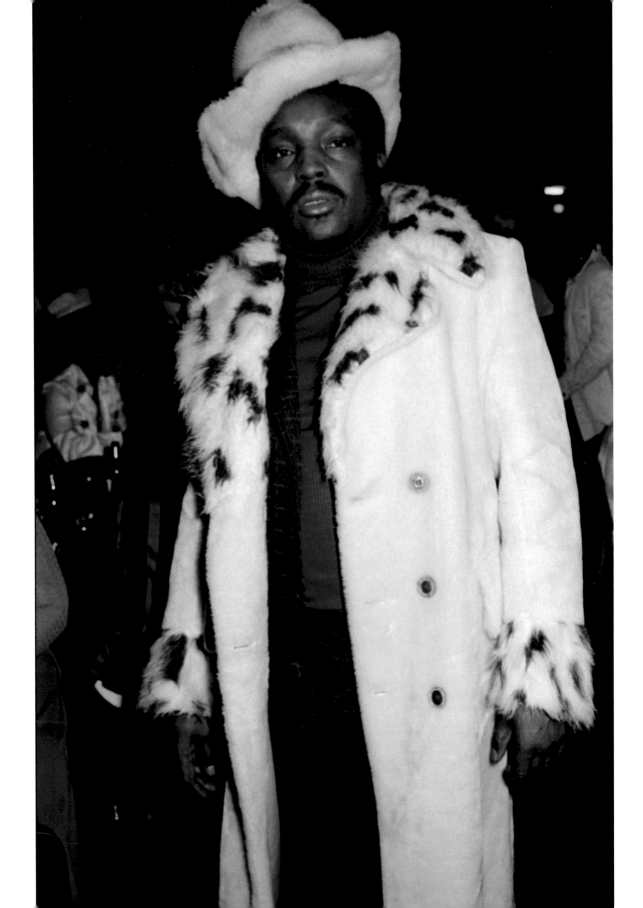

Insistent Drums in Our Backsides

He:

The grass is always greener in the other boogie,
on the other side of the room. Nobody puts their
cards on the table until the table is slicked with
bourbon and sweat, then—well, maybe. But my
eyes never stop the roam—*Look at her, damn
look at that thick one, but hell nah, check out
that one over there*—even as I'm rolling my work
on *this* gal, I see himself dancing ten downbeats
to the right, already pressed all up against some
other miracle, some other swivel. Behind these
shades, I can plot my whole night, the wiggling
lineup of breasts and butts and bobbing heads,
and I don't miss a beat. I'm promising myself
to her and her and her, grooving the whole time.

She:

I will not take my eyes off this engine, this
magic, this popping and spark. It's been too
long since I've been this close to a man who
sways like this, like his mind fixed that I'm
the girl he can't help but crave, and the proof
is in the slow roll, in the roll and rock like
ocean waves move then they really got no
place to go. I'm all up under his hex, eyes
locked on it like it's the antidote, and tonight
maybe it is. Jesus, when this song ends, hope
I can stand up, hope I can break this spell.

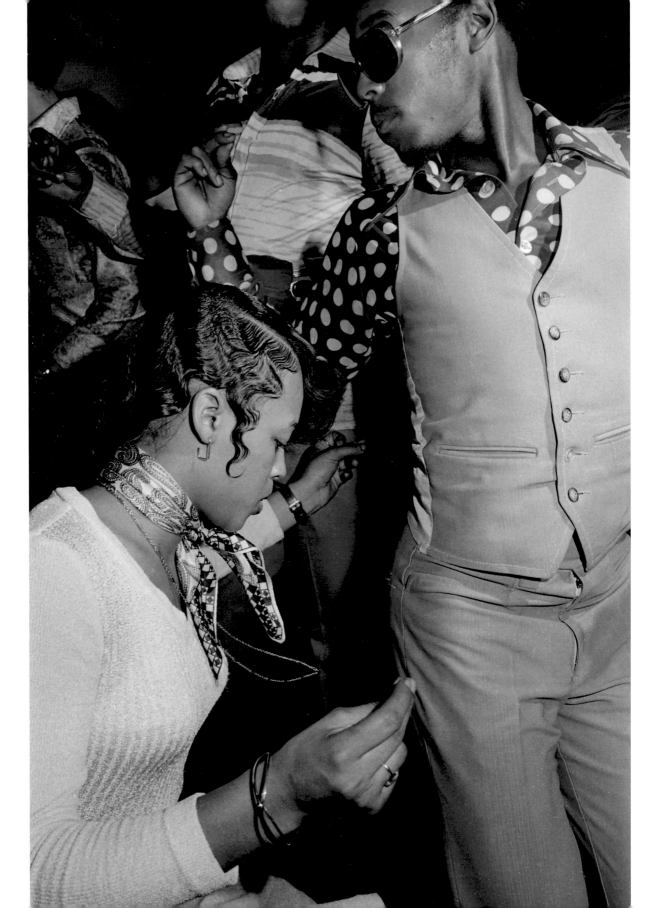

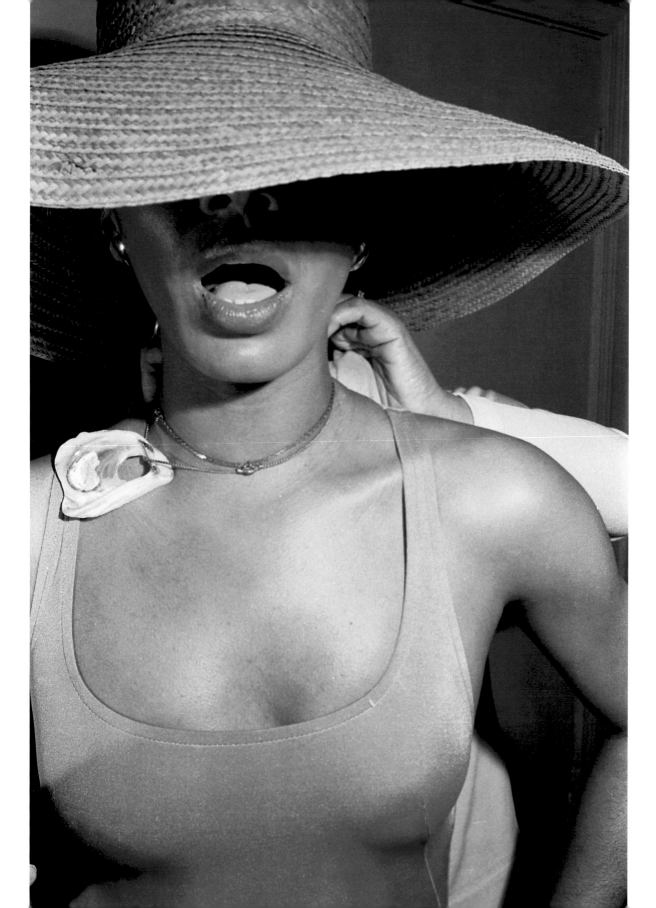

The moment of touch, the instance
of skin and skin, it's amazing to realize
that we go so many days without it,
how many people we pass on the street
and how many times we don't reach out.
We live in the center of our own drumbeats,
convincing ourselves that the drum
is linked to other drums, that we are
in a country of open arms. Then, one day,
someone breaks through and really reaches
us, touching our shell with the sizzling
pinpoint of a finger. *I'm here,* they say
again and again, because we are learning
a new language from its very beginning.
I'm here, I'm here, I'm here.

A man sure can bring glory to a room
just by bowing on that first downbeat,
just by shutting his eyes in supplication,
just by knowing how graced the moment
becomes when a woman's beauty makes
him bend his back, when even he can't
believe the *Please* that drips like a honey
from his asking. And a woman sure can
bring light to a room when she remembers
just how much of everything she is, when
she rises from barstool or throne, when
everyone else disappears, when she says *yes*.

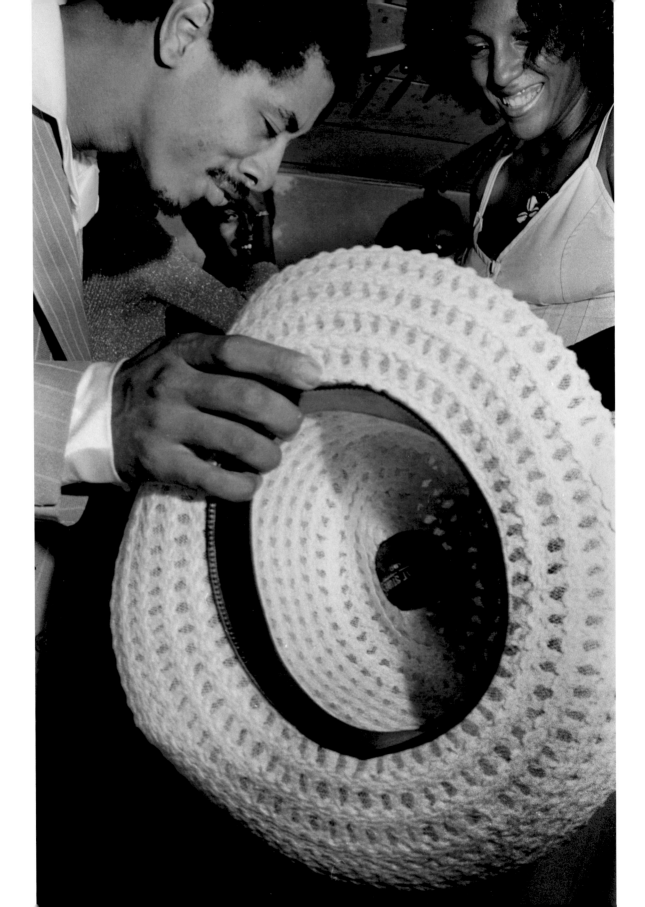

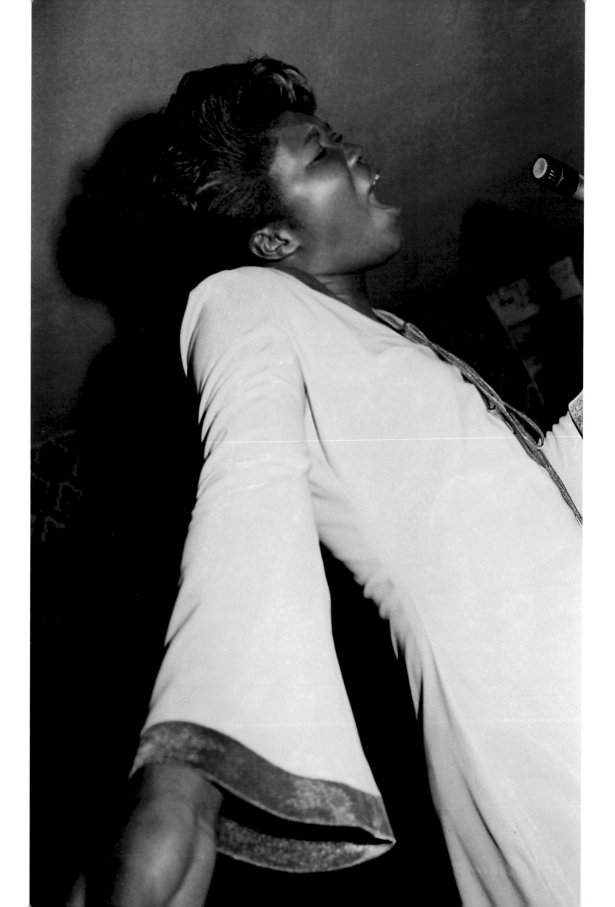

I don't mean to scare anybody with this
bellow from the base of the body, this unreeling,
the reach for the rafters, this soul that shakes
even me. I didn't know it was going to come
out this way, all unleashed and tearful, I didn't
know I had this in me, didn't know I'd held
this much in, didn't know it was time for it
to hit the air and change it. I'm sorry if this
was not the night you wanted this, if you just
wanted to come in and have a drink and not
think about the hurt outside the door, I'm sorry
I brought it in here, sorry I wailed it into the mic,
I didn't mean to scare nobody. But I needed
to scare everyone. I needed to scare myself.

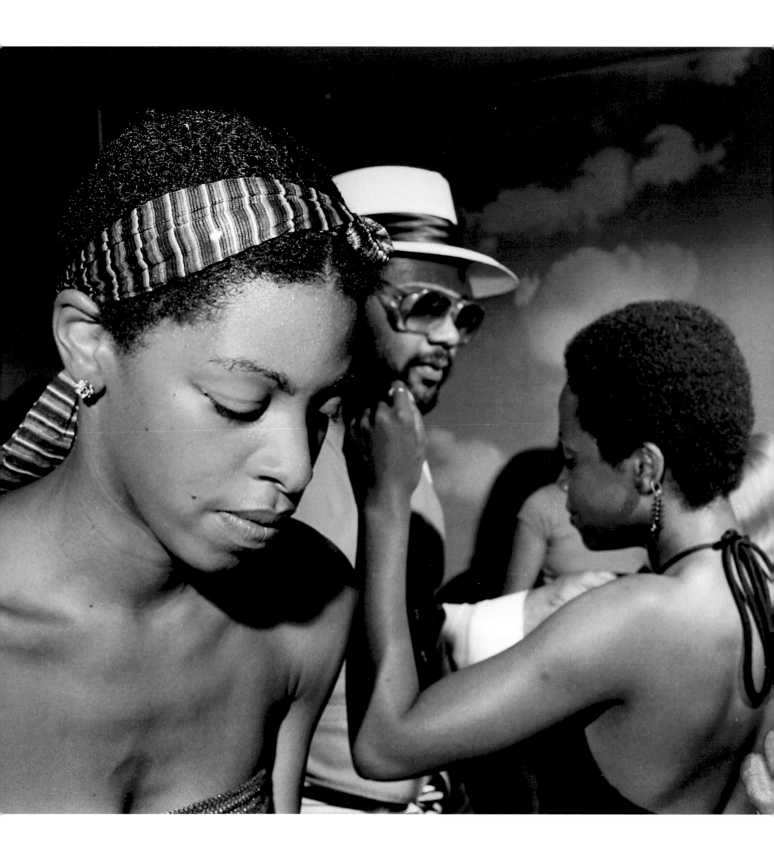

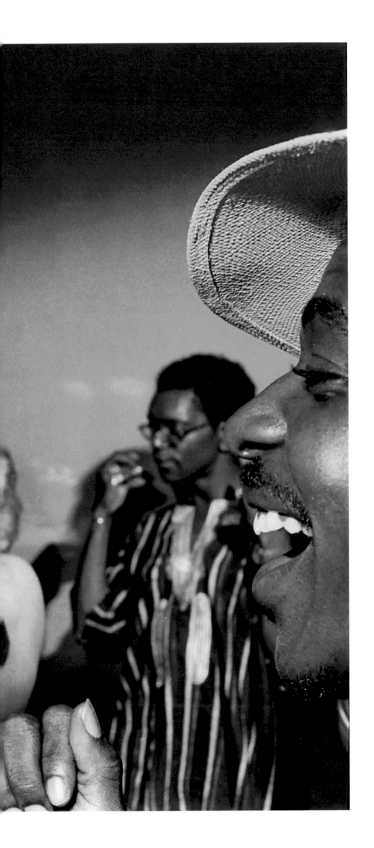

The question is whether or not a woman ever
really knows her own beauty,
whether she can stand facing a city
that's fixed on finding ways to change her,
and say her own life aloud.
That name, a slow unfold of southern light,
is the name her daddy gave her—and when he did,
he knew she would spend long hours
asking her mirror to give something back.
He knew she'd be a Chicago girl
who'd one day drive her fist through the reflection.

It's the beginning of the night.
There's a roar every time the door opens
and another player walks in, there are hand slaps
and fresh drinks being slammed down
in greeting. The women still smell
like Maybelline and smashed roses,
the men like tobacco and spice
and peppermint they crush in the back
of their mouths. The music is slow
right now, giving everybody a chance
to find the battery in their bodies.
Everywhere she looks, there's a mirror.

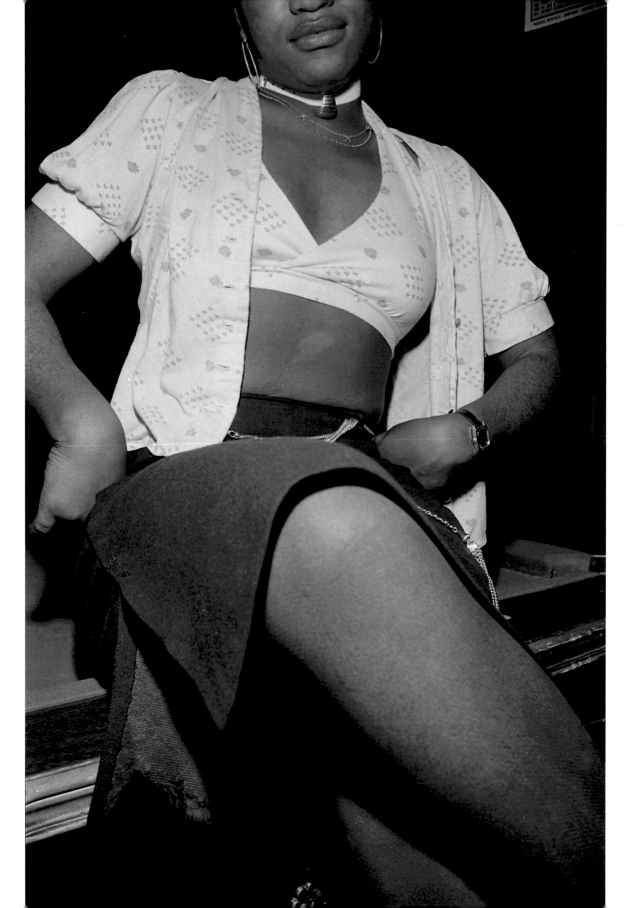

You put a dip in your hip, you let your backbone slip
You keep your eyes on the prize and make his nature rise
You set your mind on the grind, you make a man go blind
When you score on the floor, you'll make him beg for more
And when you snare with a stare, you know it just ain't fair
You put a dip in your hip
You keep your eyes on the prize
You set your mind on the grind
Then you score on the floor
You snare with a dare
You let your backbone slip
You make his nature rise
You make a mind go blind
You make him beg for more
You know it just ain't fair
Ain't fair
Ain't fair

Joe Tex once sang *I don't want no woman with*
no skinny legs no matter that she's hitched
her skirt up to heaven or that her feet are satin
and bow-tied. Folks know that song. At first
glance, she is bone clacking bone, no meat
to grab hold to, nothing to give that slinky
skirt a job to do. It isn't until she uncrosses
and stands. It isn't until she stands and stands.
It isn't until she whispers 'bout where those legs
go. It ain't like Joe Tex was singing 'bout that.

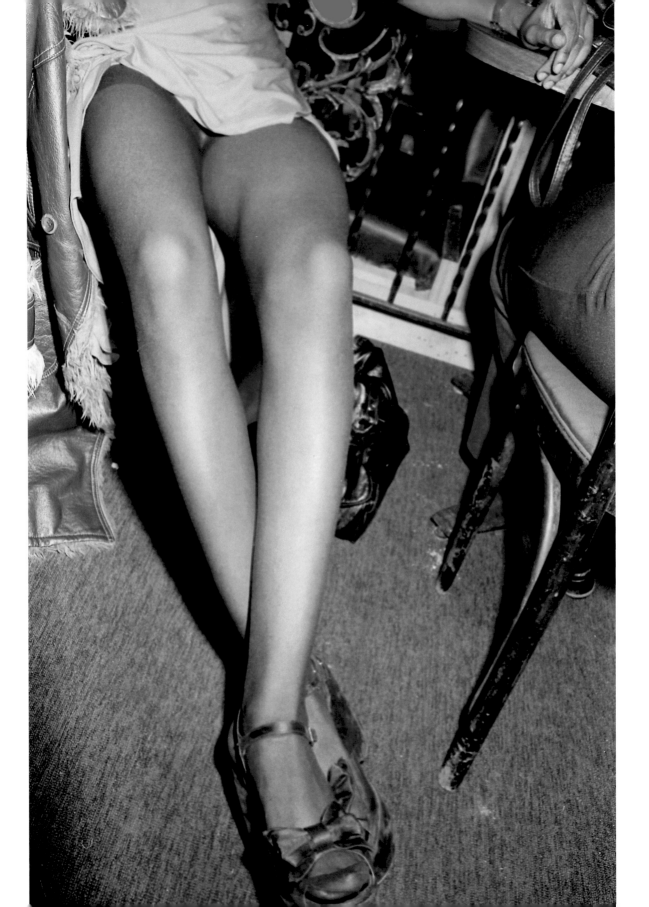

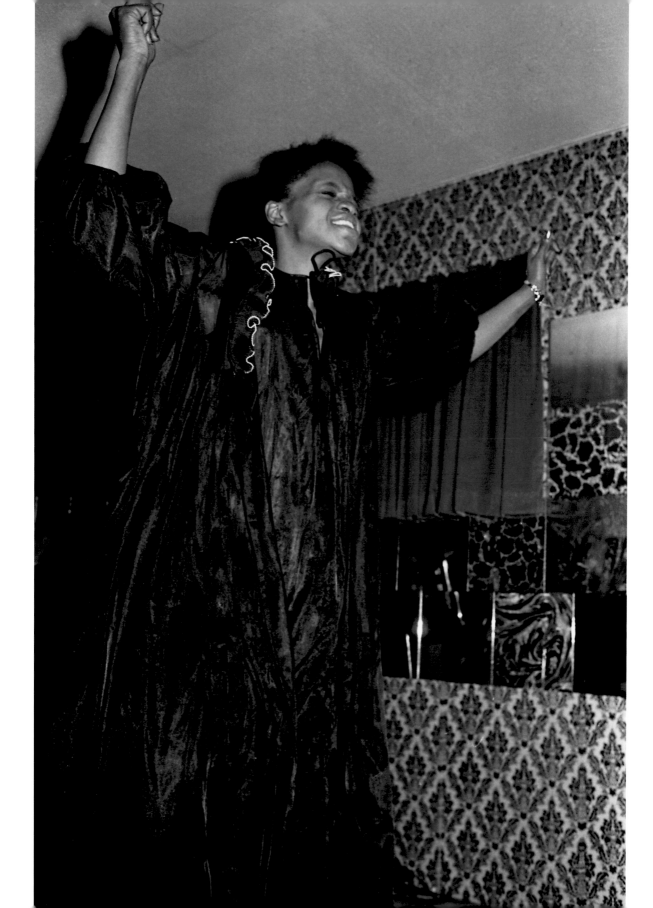

There's a reason it's called *going to church*
when some wild somebody is every bit
of fever on the dance floor, when that head
is thrown back almost off the neck because
the DJ is digging so deep down in the dirt.
Only difference between the club and church
is those strangling pants, those crazy-colored
skirts hiked riding up on thighs. Only difference
is the organ has gone round beneath the nub
of a needle, and looks like everybody done
sewn the hymns into their hips. Every stage
needs a preacher to make Saturday night
look more like Sunday morning, every stage
needs a whirler to say that all sin is in the sweat
of the beholder. When they scream *Last call,*
it ain't always about whiskey. Sometimes it's
the gospel of a loud clock, tickin' you home.

There's a certain kind of smile that hides
a certain kind of terror. It's a wide smile,
stunned and exact, flirting with an unreel
scream. It may be trying too hard. It lives
in a shiny, cherry-scented circle of its own
blood, it hurts the mouth. Some smiles hide
everything and nothing at all, they march
in place and horrify everyone who sees.
The smile becomes the spirit of the blade
in the glass, all that wet and blatant hope.
The smile becomes the whole face, the
hardwired hair, the drooped and desperate
body. Look long enough and all you'll be
able to see is that frightening jolt
of white, the whispered *please please* of it.

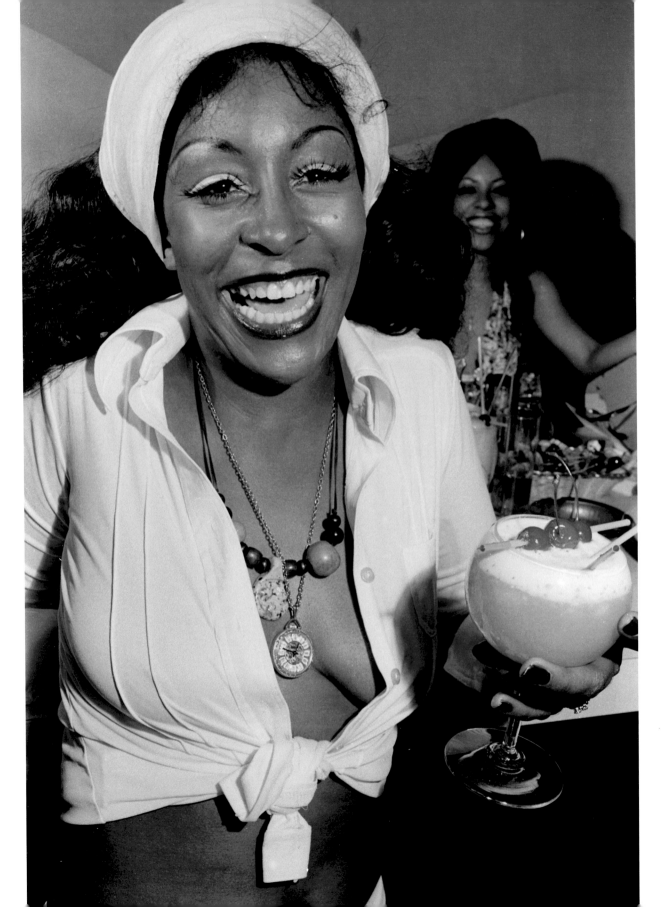

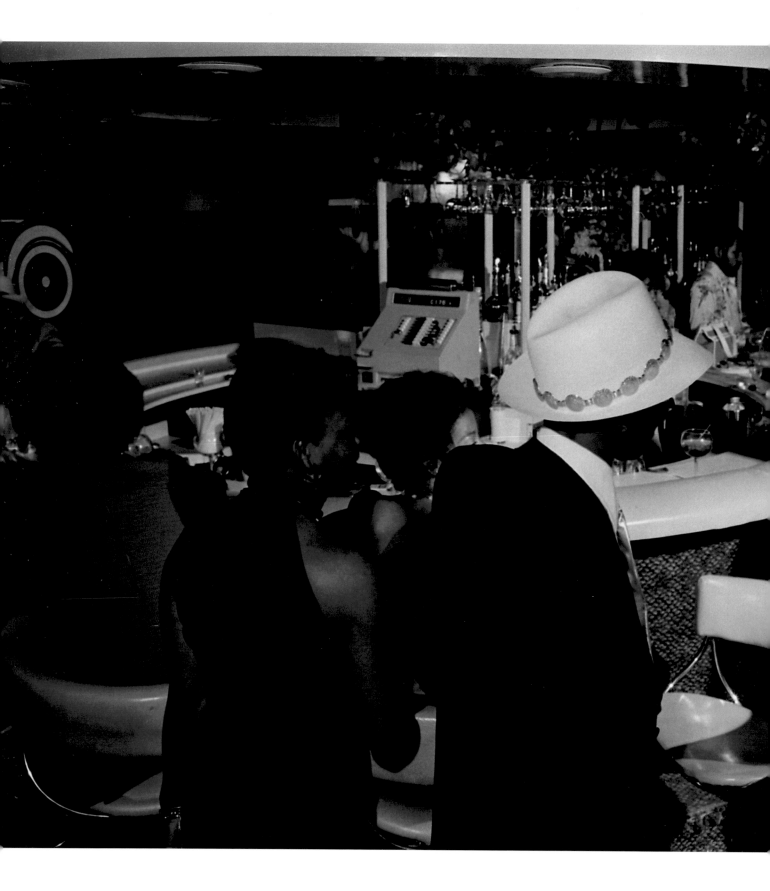

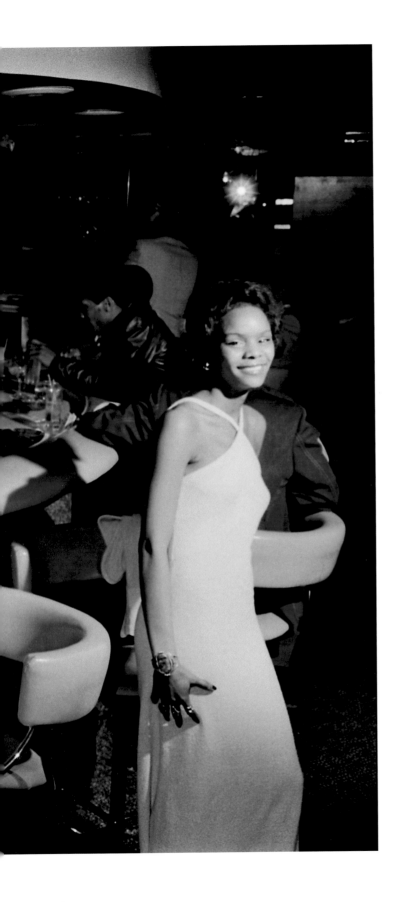

Finally, I am old enough to have my
own spotlight, my own dapper possible,
to walk regally away from the drink
and toward a drink. Everything about
me is new, brazen, doused in a gold
I'm not sure I can handle. Just yesterday
I was a child running headfirst into
the throats of alleys. I was all skinned
knee and stumble. But I awoke one
midnight, and I was primp, plumage,
I was a bird. And I step out in my own
sun, and his eyes, his eyes, they follow me.

And the Club Keeps Humming

You got a whole lotta need for this. When a woman slides her hips across your leather seats, you want this kind of overwhelm. You want African spices and the wild way sugar smells. You want your ride to smell like money and good lovin'. And what I've got here is the original— there are fools out there imitatin', promising the original stink, but look in my eyes, look at the sweet droop of my business suit, look how my hat teeters on the edge of crown, and I know you can see where Jesus is in my life. I'm where your trust should be. I'm selling you a free ticket to a sweet ride—hey, it works for me. Look at my hair on blaze, angled and perfect. Look how the women's eyes follow me 'cross the floor. I smell like your car gon' smell. Buy me one a' those deep drinks you drinkin'. Maybe we'll talk discount.

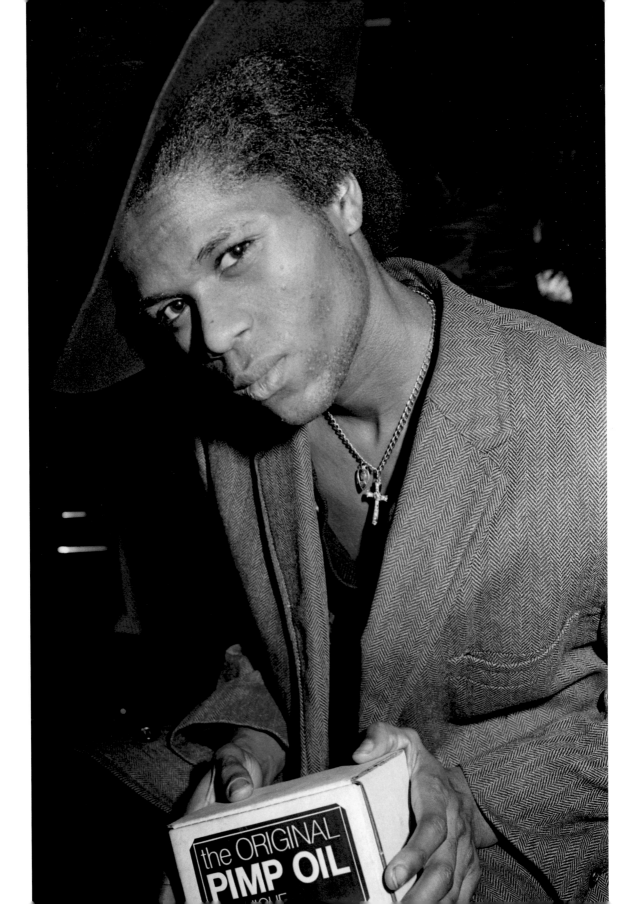

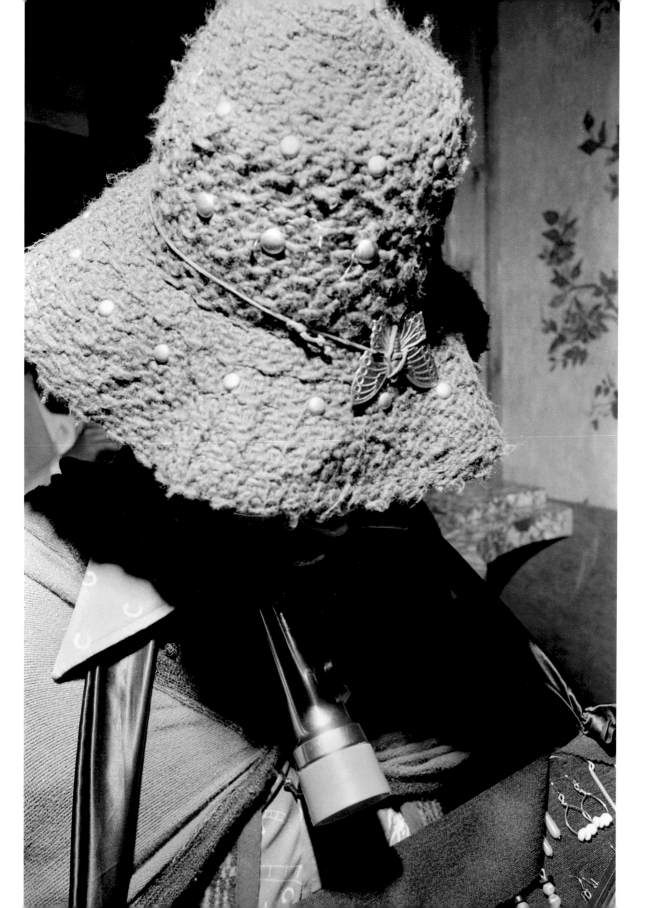

I sell you your shimmer
I hawk what makes you feel
rich, what gains you entry, I
am the club's stab at commerce
I urge you to spiff up
your fingers your necks your wrists your toes
You know what they say
gotta glitter while you can glitter
I pitch status, I sell
you short-time gold
and overnight green
I'm peddling you what you need
tonight
Not tomorrow
I am not in the business
of prettying up
tomorrow

I serve up shimmer
I serve up what makes you feel
rich, what teases you with entry, I
am the club's certain commerce
I was driven to adorn
my hips, my chest, even my feet
with the only color that blinds
You know what they say
gotta get the glitter while the glitter's good
I suggest status, I woo you
with short-time gold
in exchange for green
I peddle you a need
tonight
No need in you thinking
'bout what you might need

tomorrow

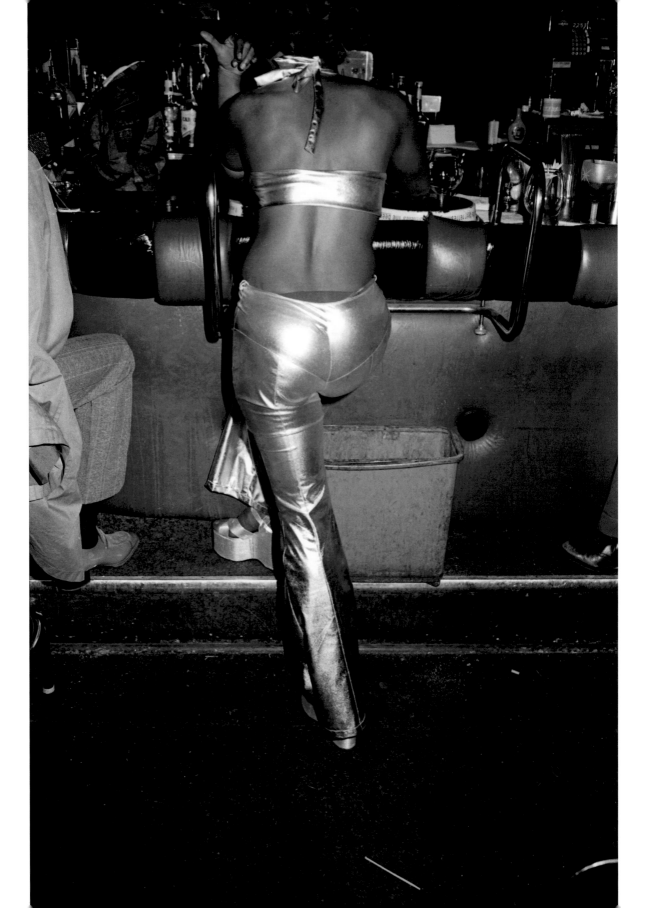

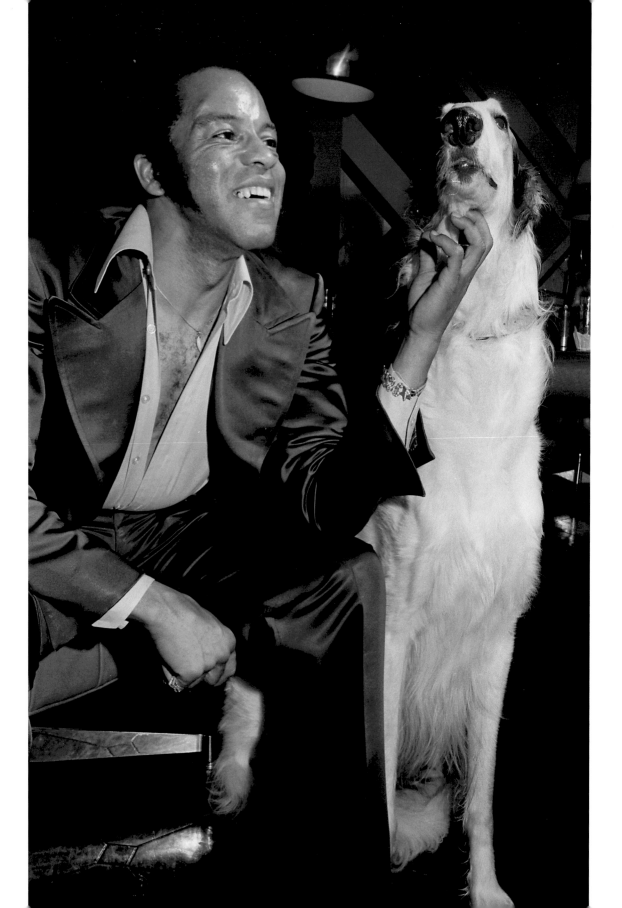

Man's best friend in the club tonight making
his best friend look good. The ladies coo
and flock, scratching his skin through silk,
sometimes letting him lick their made-up
faces. Slinking the floor, he taps thick nails
on the hardwood, rubs his sleek body against
nylons and sharkskin slacks. Claims his right
to a fallen feast of pork rinds and ice cubes.
Man's best friend in the club tonight making
his best friend look good. Brother who owns
him don't have to do nothing but be nearby,
grinning, smelling good, flashing his own
chest fur. The mutt's better than a good rap,
drink money, and a car. *Woof woof, girls,* both
dogs bark. *Come on here and see what I got.*

We spend our lives hunched over what we're sure is the perfect shot, waiting for the clunk of balls in a busy pocket, the gratifying crunch of bat against ball, the sweetest slip of the ace into our palm from the top of the deck. For a second of numbing focus, the world cowers in unbreathing backdrop, waiting to see if we can triumph just enough to walk upright through another day, if we're fools enough to believe that a winning hand has anything to do with winning. Maybe it's the focus that matters most, the fleeting instance when all time is reduced to one shuddering second which is the same way we look to the world.

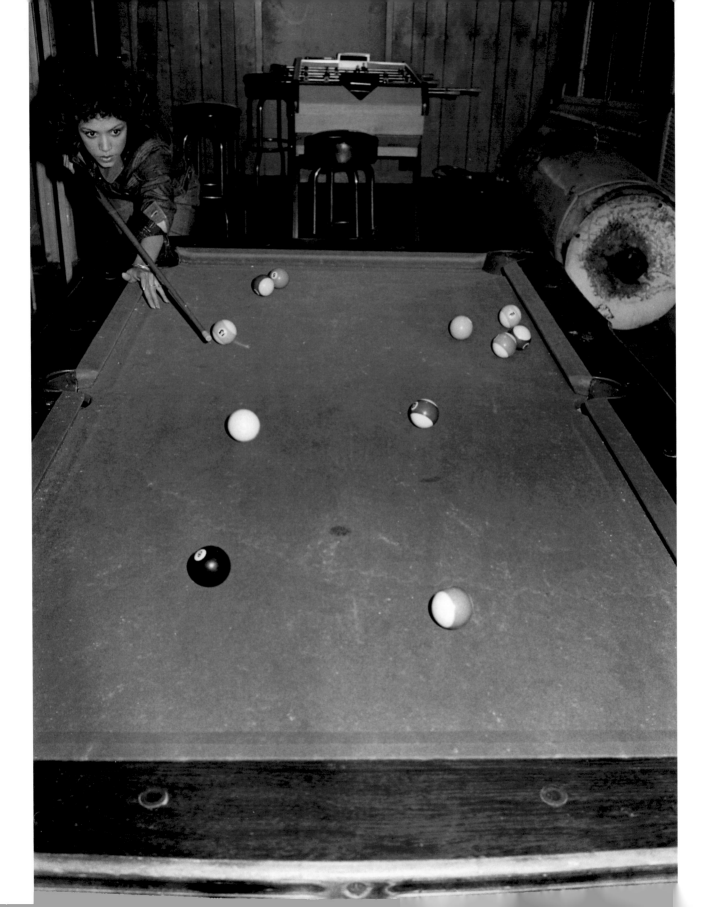

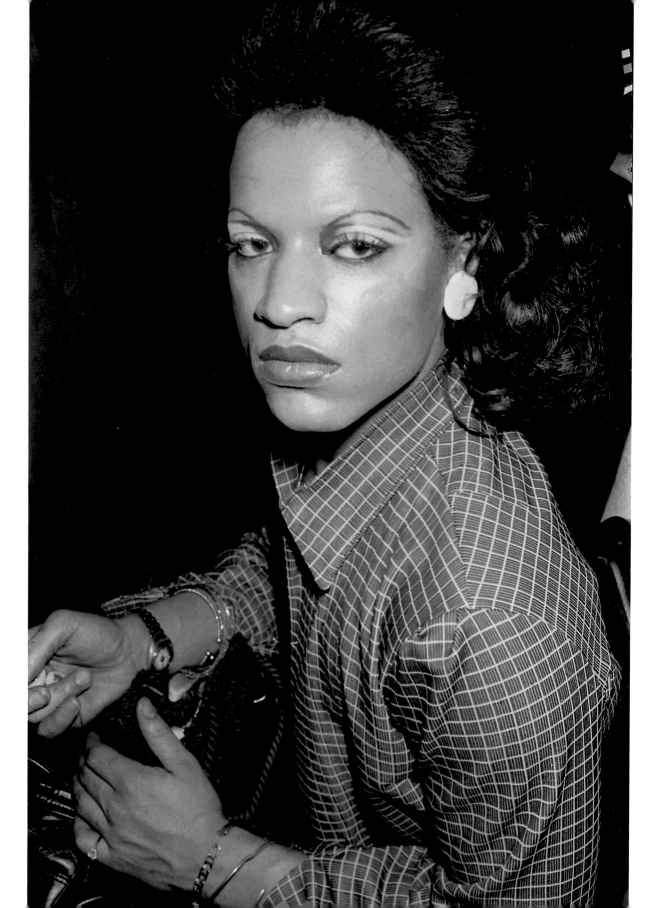

Don't you dare open your mouth to say
what you think I won't cut you for saying.
Just look at the blades my eyes are.
I am the overwhelm, the fierce beauteous,
I'm what you dream but are terrified to utter.
Best to trip your way back across the crowded
floor, best to look for that woman you came
with. Bury your nose in her shield of perfume,
dance with your hips fitted to hers. Don't think
about the secret I spit into your ear. Don't think
about my mouth and what I said it could do.

The dimple, the tiny overflow, the sweetest
of imperfections, so uncertain the mirror can't
find them. Once the body is in relentless
motion, it's all a hungry blur, the hooting,
the hesitations, the hurried dollar bills,
the necessary engine of the brown body.
Every night there's a fleeting look at what
is offered. Every night it is just enough.
There's nothing to do about what is wrong,
what isn't taut and snow. This is the club,
and everyone knows what's waiting. All of it
is everything. It is flawed, and it is perfect.

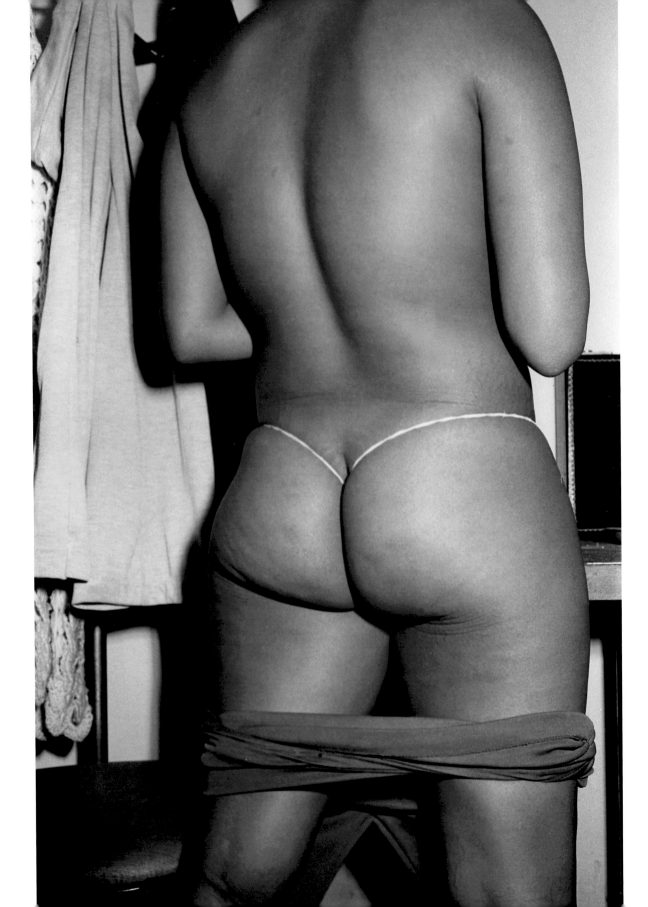

What I wanna do? Sit down in a circle of ash and have
a good long chat with the sax man, maybe I can convince
him of my hollow, maybe he'll see fit to blow story
straight down the column of my body. I was hoping he
could plump each cell with stories my mama says she's
forgotten, stories stringed with fatback and red dust.

No matter where you think you come from, the saxman
was soundtrack when you popped slick and bloody into
this chaos. He surely taught you where your hips was at
and what they was for, he taught you sass and the reasons
for whiskey and pork. Nah, I don't wanna hear how they
hold what they hold like a man holds what he likes to hold,
how even when they're not playing that thing, their hands
glide along it, south to north and back, how they name it
and bring it to gleam with slow fingers. I don't wanna hear.

Every other horn ain't nothing but heavy and shine.
The sax man cometh.
The sax man cometh.
He burns it down.

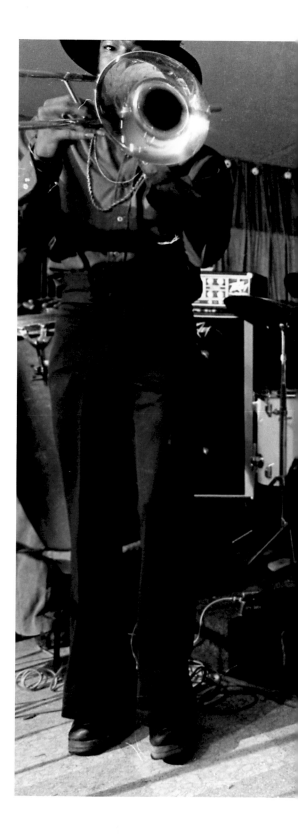

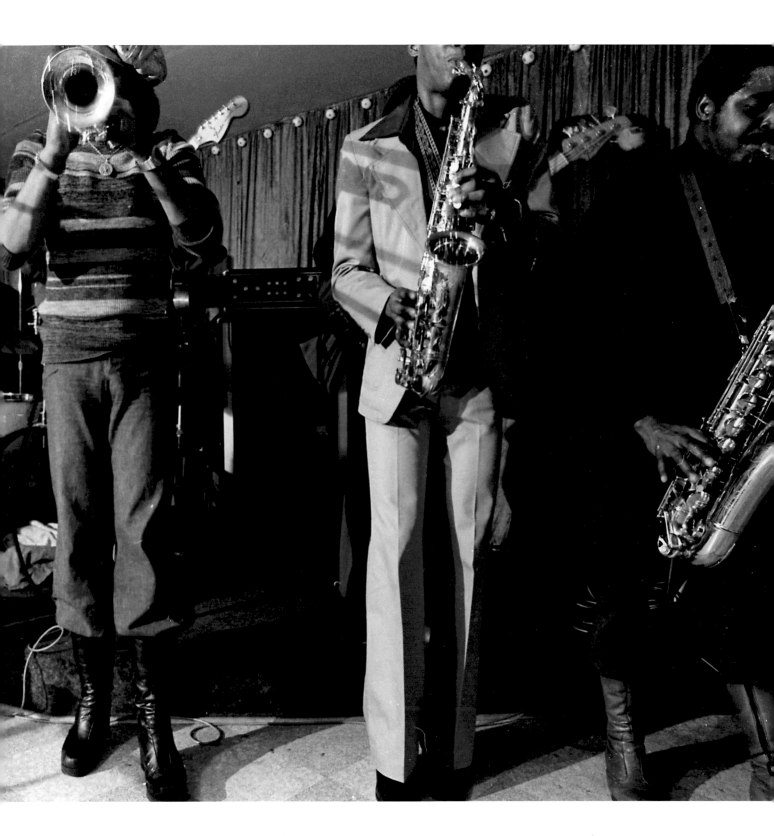

What the Night Has Conjured

The demon is in the details.
The answer we were looking for
leered from the bowels of a smudged
glass. It blurred and kept calling, and we spent
all night searching for the promises it made. The answer
took root as a flame in our bodies, and it burned us down from
the inside. All night long, we breathed ash. We fought to cool ourselves
with fuel. When the lights came up, when the man yelled *Don't know where*
you going, but you can't stay here, we were the only things left in our seats. We were
in drunk love, dimmed and spinning, still asking a question that was answered all around us.

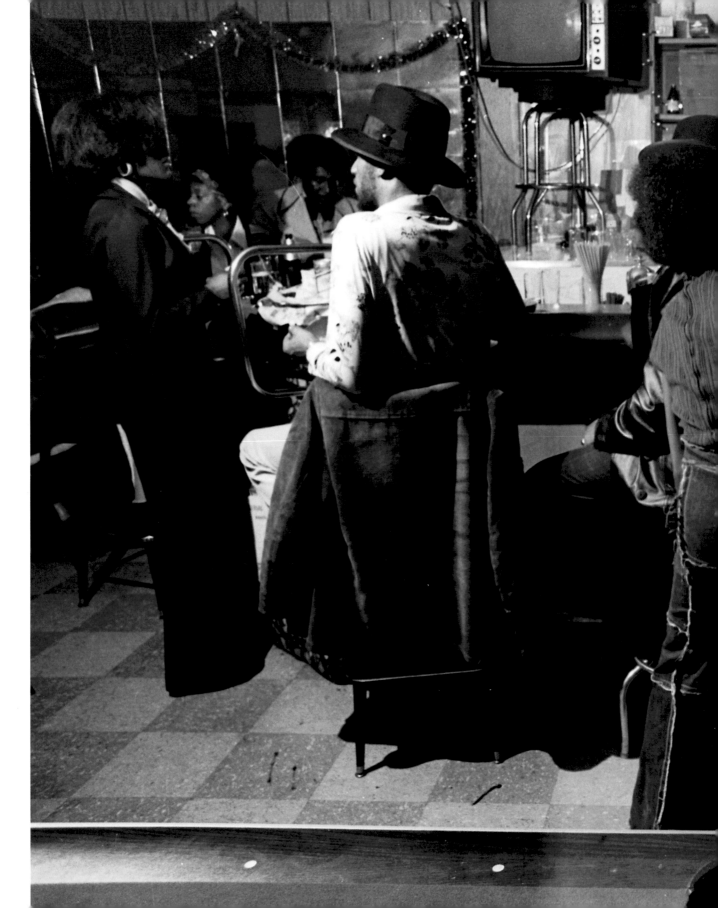

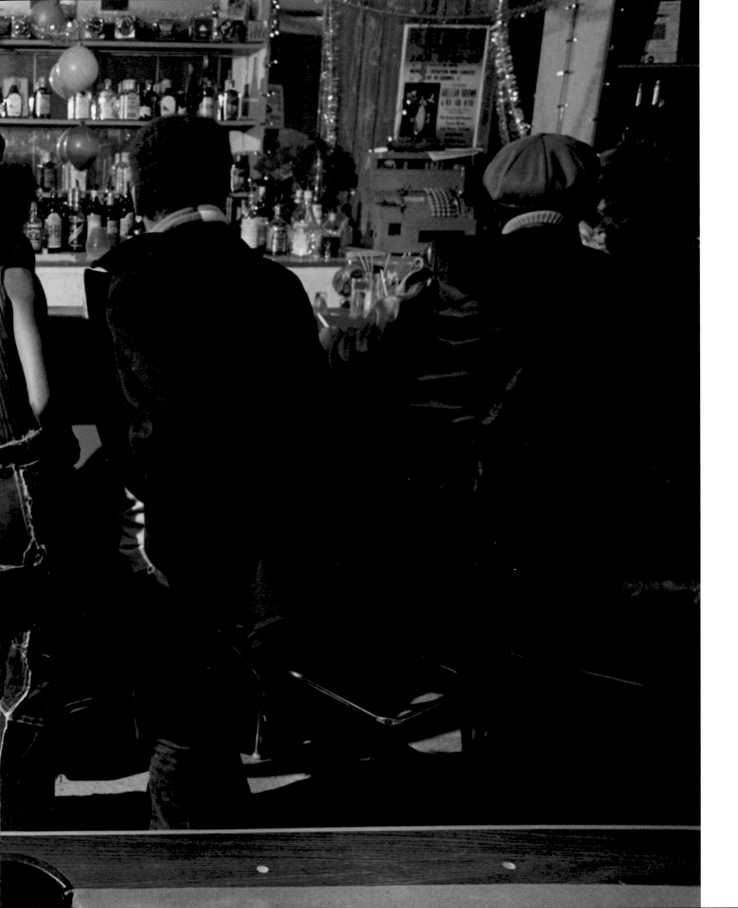

It is the clutch, the warm cup, the discreet squeeze,
the wanting, the *gotta have it,* the spread fingers
on the stunned ass. It's the claim, the rooting, it is
what last call always claimed it could do. This kind
of blatant link on a place so owned can be stutter
or an unsheathed knife. It just may be a lie. Or, if
we are to believe in tonight's version of love, it could
be the kind of lie that lifts you both from your seat
and walks you, terrified, to the door and into the night.

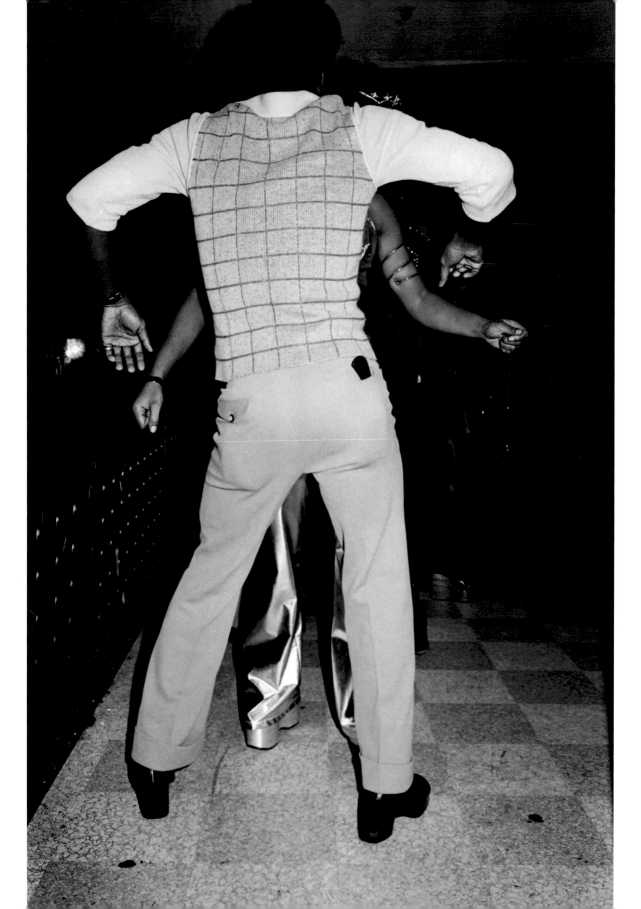

It took all night, but here I am finally gettin' down
with the child they call limelight. The time don't
matter. The song don't matter. All that matters
is that I remember to keep my eyes shut tight
because to open them is to lose them. I trust she's
here with me, linked to the drumbeat, spittin'
an overwhelm of gold, because I ain't nothing
but fever, pure fever, and her whispered *yes*
was as certain as a vibing wire. I don't know
where the night's going from here, but I'm riding
its whole golden road. And when I dare open my
eyes, and there's nothing but darkness, I'll know
the sweet blind can be. I'll know I done right.

I am about to sigh something to you that
I will regret. It will be practiced and fragrant.
It will most likely be a lie. It's just that the music
is forcing me forward, your shoulders are damned
hypnotic, and who remembers what we say here
anyway? So please listen with half your heart.
Don't take root in this vague promise, because
I doubt it means anything further than tonight.
I am about to whisper something to you. Take
it as seriously as you take this song. What I say
will make your body move like fluid, it will coax
you back and back against me. What I reveal
will already be something that is about to end.

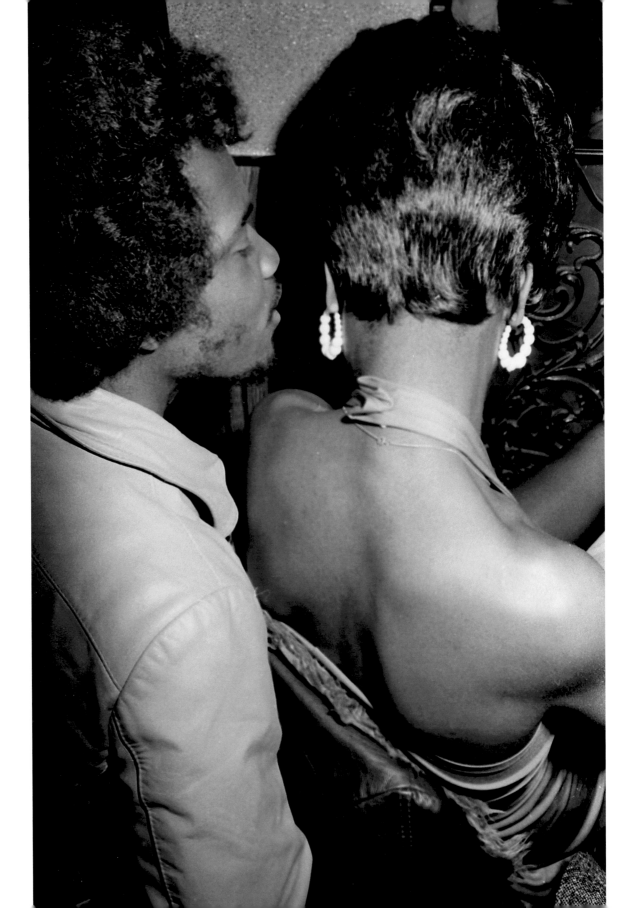

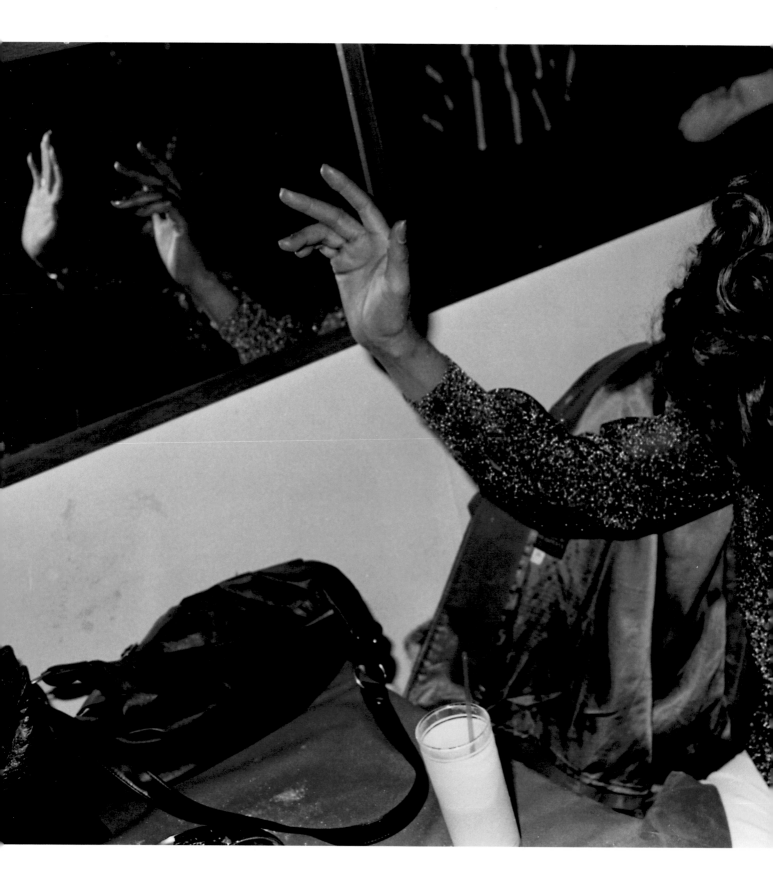

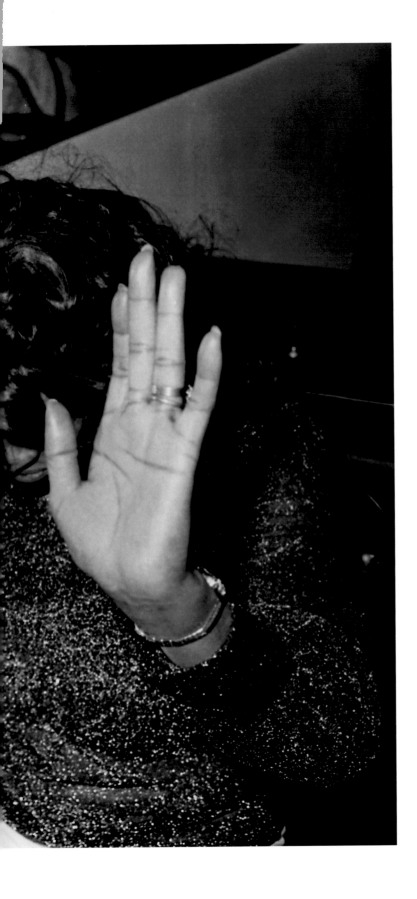

Could be two reasons to testify, and don't
know which one got ahold of me this time.
Sometimes Jesus finds me swaying at my
favorite table, all fevered with some man's
hand reaching for my light or my neck.
Aching to save me, He raps in tongues,
moves like a hot needle through my body,
makes me throw up both my hands to pay
witness to everything good He gave me,
everything good He's lettin' me keep.

But my other reason to testify might be
whatever threw that nasty punch from
the bottom of this glass, it just might be
that gold water with all those teeth in it.
That swallow I just took deserved *all*
the praise. Taking the sting out of last call,
it moved hot like the Lord through my body.

Things ain't going the way they sposed to.
She ain't sposed to be wearing that dress
she wearing, and he ain't sposed to be all
up on it. I'm not sposed to be sitting here,
this mad, this early, alone for this long.
I ain't sposed to be holding my coat like
I'm half in and half out this place, like I
can't decide if even this man is worth it.
Things was sposed to be different. I was
sposed to be in his arms 'cause they were
my home for the night. I was sposed to
be a little drunk, a whole lot of sparkling.
Things sure ain't going the way they
sposed to. Heat rising up like a lit match
inside me, my one hot hand shaking 'neath
the table. My lying mirror didn't talk to
me 'bout this this morning. Damn, now I
got to decide whether I'm sposed to slap
somebody or just pick up my life and leave.

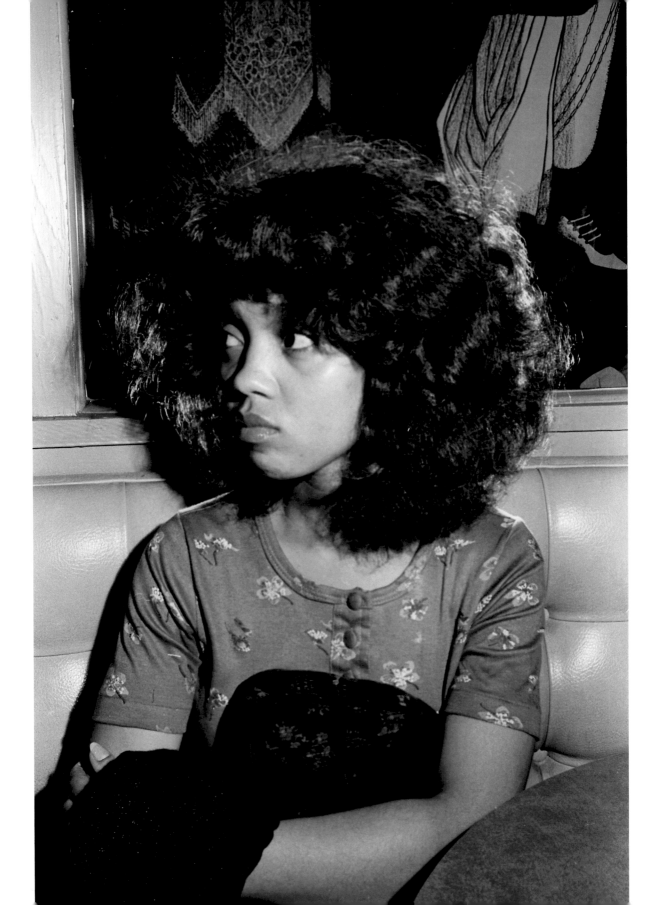

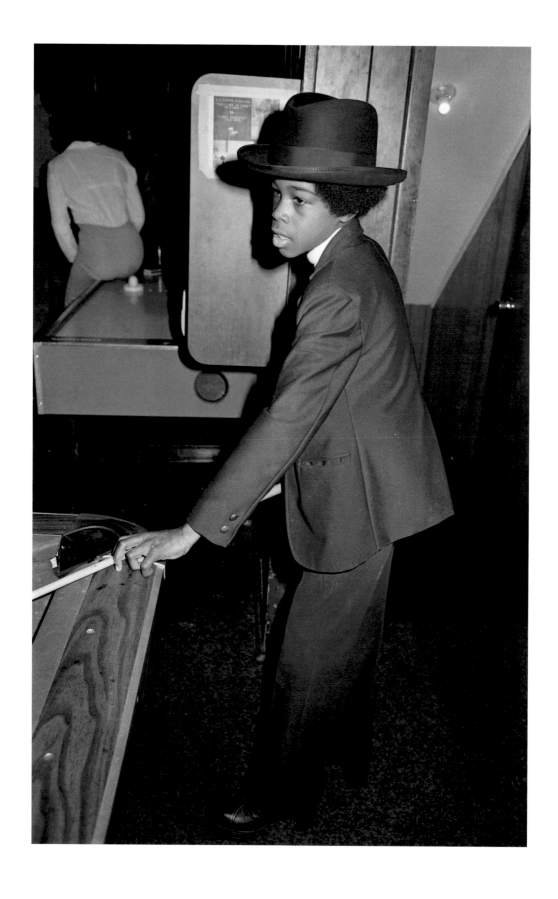

There are times I wonder if what I am
was worth what I missed: I skipped soft
food and sandlot, backslaps and cap guns,
the swagger of superhero and Saturday
morning cartoon cats who died funny
and over and over. I wiggled from the
sure certain of my mama's arms and went
looking for winking neon and the slim
cool of a cue stick. I'm gonna stop thinking
about who time says I am. I gonna just
keep moving like a man moves. I will say
my words deep, and I will grown into this night.

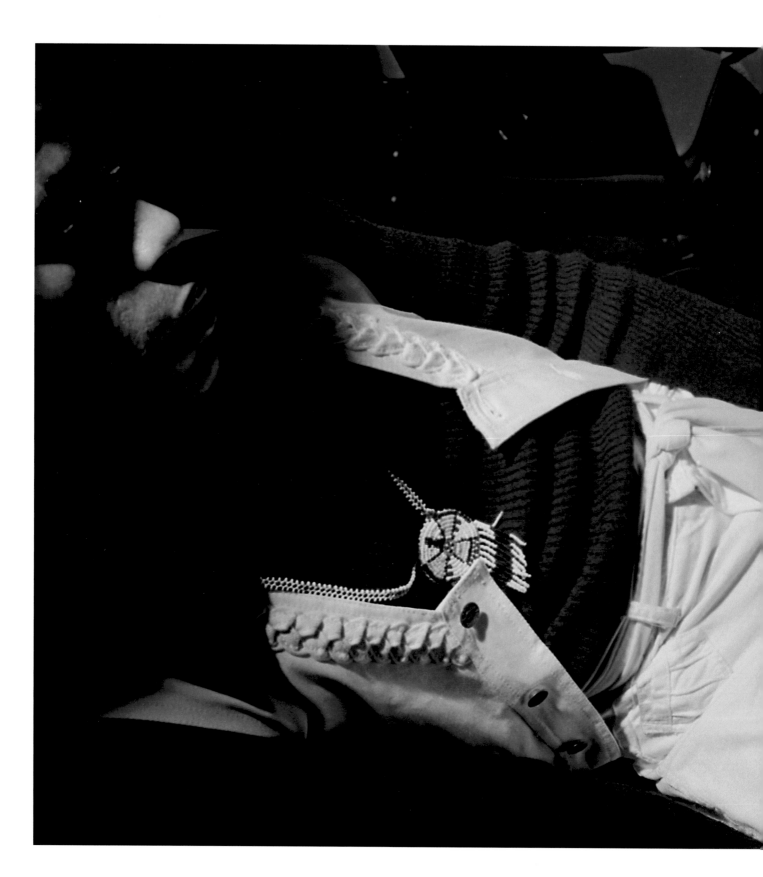

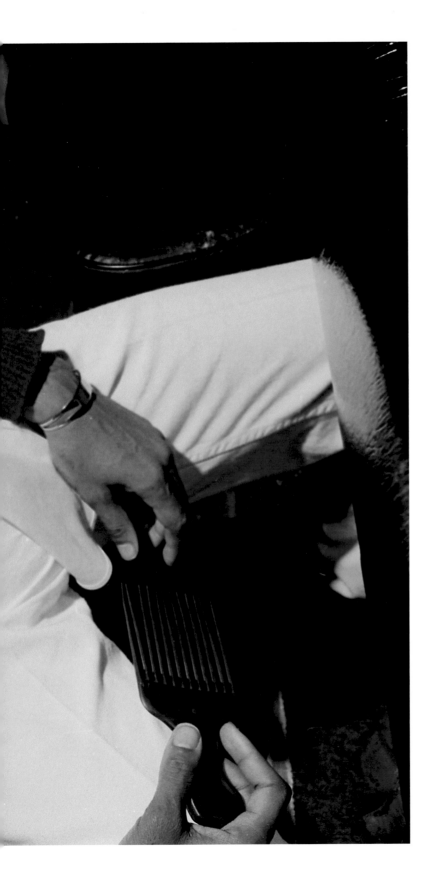

That second when the music stops.
That instance when you have to reach for your own name, when you look down and see that there's been no need to move for hours. Sometimes, right in the midst of a room's heat and motion, your solemn work with yourself is all that matters. To be reminded of just what kind of man you are, you need to stop and be still in darkness—until you find the strength to conjure your own light.

There is more than one way to exit a room,
and this is all of them. No need for a last
dig this over the hunched shoulder, no need
to stop and acknowledge the snotty weeping
and moaned supplications in your wake—just
serve up one final gut-wrenching glimpse
of that engine, slow-smoldering, crammed
into a silk space that shudders. No reason
at all to quicken the undulating stroll. Part
the curtains, and with a whiff of spiced smoke
and the wheeze of a strained but thrilled zipper,
be gone.

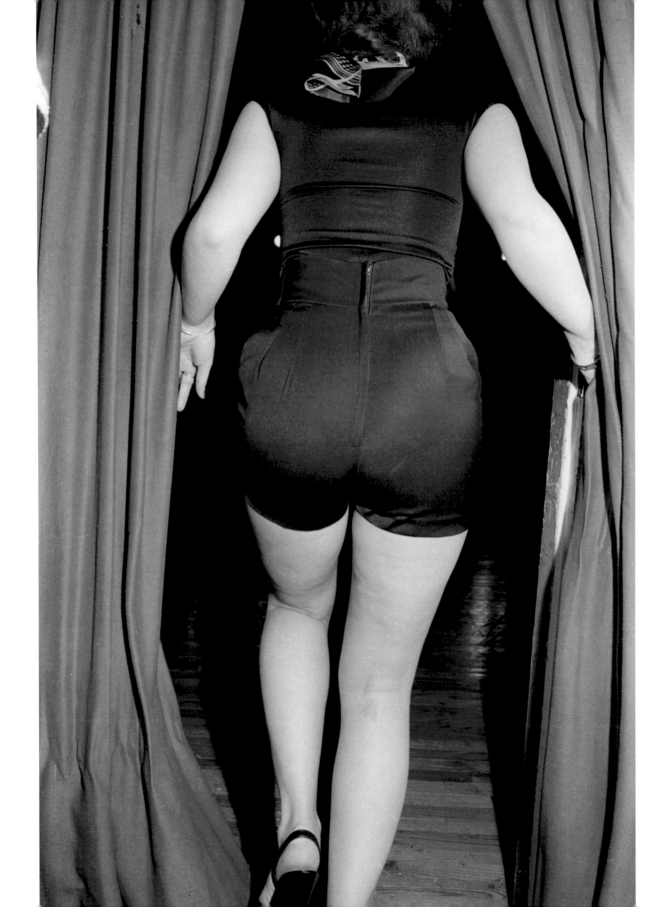

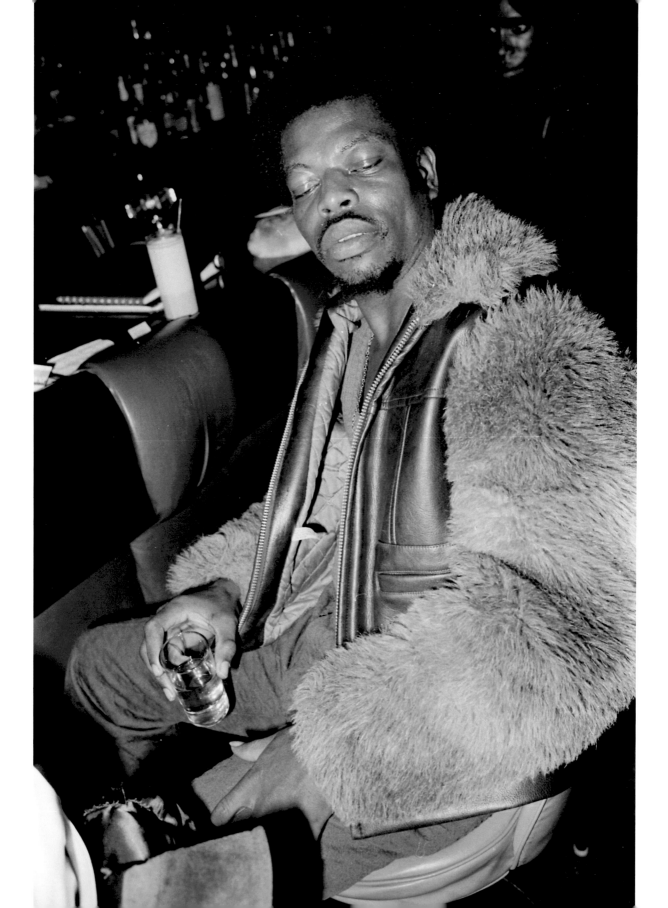

The (nearly) snoozing befurred warrior surveys as much kingdom as he can from his spinning stool. The point where the slitted eye conjures mystery was hours ago—now 3 a.m.'s coming on fast, and the bobbling glass of spirit is more nightlight than anything else. It's been a long meandering midnight in stifling skins that would just be weakened by too much underneath. The choice to slump or sizzle is getting easier by the minute. Is this heatstroke? Did somebody turn off the music? Did the whole night go home without asking the warrior? Did the . . .

Get away go

away

any way

anyway

Fold your

crave
into a wind

that may
 or may not
carry you

closer to

farther away from
 what you run toward
 what you flee

go anywhere

everywhere

wherever
begin with the

night
and its sly engine

laugh in its face

until you hear
it

roar

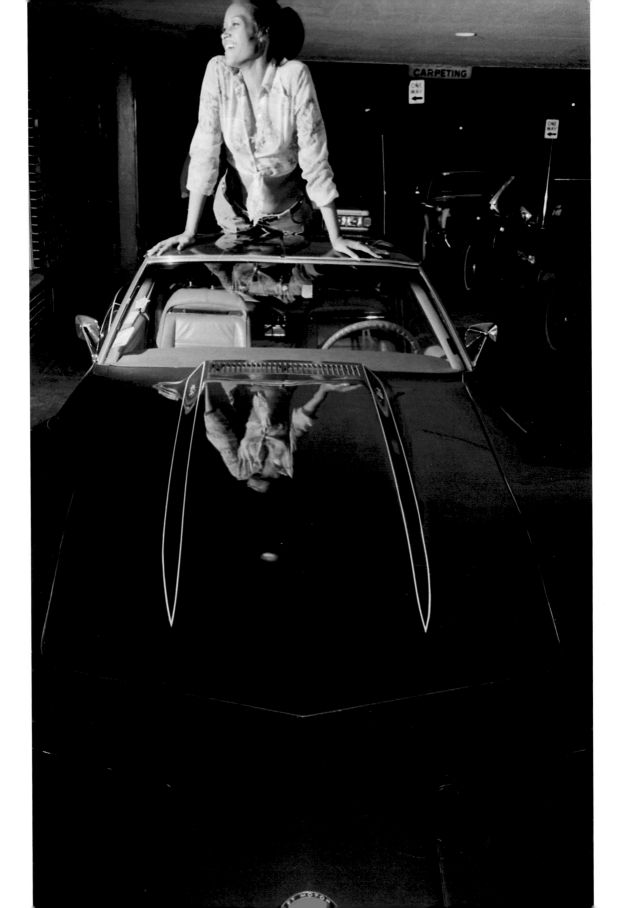

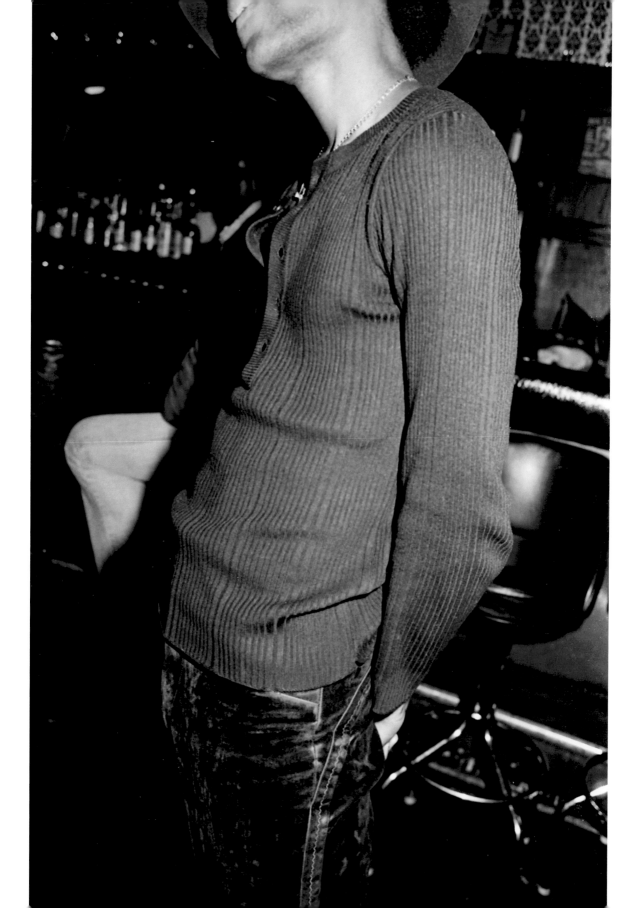

I mean it I mean it I mean you I mean us I mean
why I mean it I said it I mean it you can trust it
bank on it bet on it believe in it I mean you I
mean you I mean now I mean us just look at
the tilt of my head just listen to the *c'mon girl*
in my lean I mean it I mean it I mean you I want
you I need what I want I want now I need this I
mean you I mean need I need you I mean it I
mean us I mean need you I mean believe I mean
believe believe believe the mean you I need

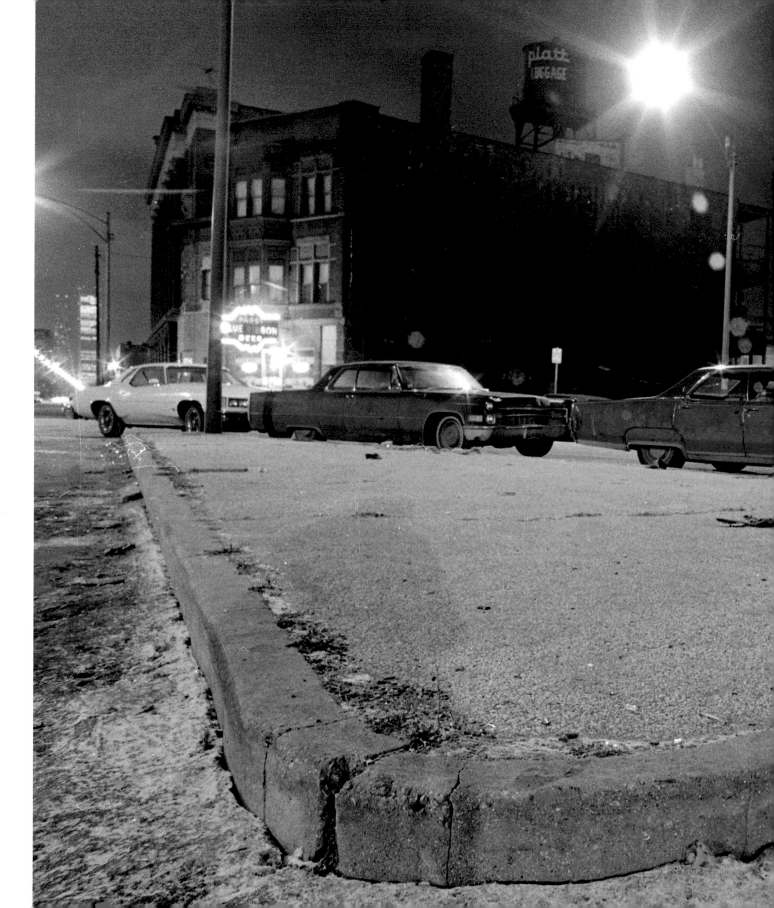

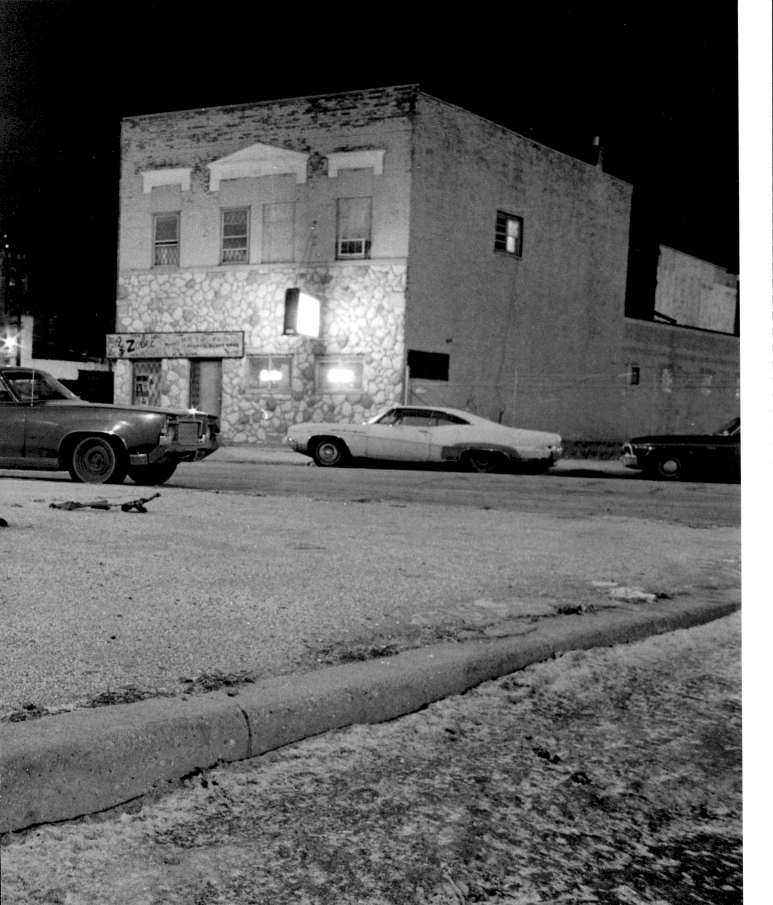

I'm black, so I can tell you and you can believe it. Here's what happens when a white person walks (stumbles, strides, sashays, trudges, wanders, traipses) into one of our spaces.

Outwardly, witnesses to this odd occurrence don't seem to respond. They glance up and then turn quickly back to their business. Nothing changes in their faces—there's no sign of hostility or resentment or even surprise. But inside, there's a hastening of heartbeat, a fleeting ripple in the chest. It's instinct—a remnant of panic held over from the days when the sudden appearance of a white face in a black space usually portended some manner of badness. Soon it's replaced by a bemused curiosity, often accompanied by an idle thought—*Lord, I wonder if that white boy's lost.* The wariness remains, of course, but it dissipates the longer the whiteness hangs around.

Anyhow, there's no way white people can resist the siren song of the club pulsing with indescribably soulful sounds and populated by swiveling, bumping, and gyrating black folks. ("The club," hereto and forever, is an all-encompassing term that can describe venues serving up blues, reggae, R & B, hip-hop, hard-core rap, Top 40, country, jazz, indie, folk—actually any manner of music that is wiggled to in any manner of wiggle or not at all. When most people say "the club," they usually mean *their* club, the one they favor and frequent—and anyone who knows *them* knows *that.*) If you're white, and you haven't needed our music in your life yet, you will. If you haven't tuned your ear to the vibing wire of blackspeak, then you have no idea what language can be. If you haven't experienced the utter exhilaration and release of a proper dance floor—one perpetually threatening to buckle under the boogie—then maybe *your* club isn't doing you justice.

I grew up on Chicago's West Side, the part of town everybody told you to stay away from, where the few clubs tended to be grittier, more blues driven, and largely avoided. And I was just out of high school in 1974 when Michael Abramson ventured to the city's South Side (otherwise known as the Colored Mecca) searching for blues and pushing open the door of Pepper's Hideout on South Cottage Grove Avenue. I never met the man, but I can just see him slowly walking in, adjusting his eyes to the darkness—*all* the darkness—and maybe muttering under his breath, *Uh-oh.*

Then he saw the wonderland he'd wandered into—men and women in their shimmering weekend regalia, whirling and swerving in the wash of neon. "I walked into a timeless place full of supporting actors and actresses of every conceivable role," he later wrote.
So he went back again, this time clutching his camera. But he wasn't sure if snapping pictures would be crossing a line, so he turned, turned to leave.

"Then I heard someone shout at me, 'Where are you going? Get back in here,'" he remembered.

It didn't take long for *the* club to become *his* club. Folks got used to seeing him, slicing his way through the dark, armed with that camera, bobbing his head to soul spewing from the juke, flashing that strobe of his to the beat of the music. In fact, there was a ripple in the force when he

wasn't around. It didn't hurt that he was wildly curious about what was beneath the surface of what he was seeing. It wasn't long before he was privy to the coded intimacy we hold so close, tapping into that need for us to know the night. He spent more than a year as a fixture in Pepper's and in other South Side clubs—Perv's House, the High Chaparral, the Patio Lounge.

Michael laughed, drank, handed out free prints, and got used to the smoldering sensuality, relentless beat, and unbridled glee. He got used to hearing his name called out loud. He got used to being welcomed and encircled. As time passed, clubs closed, moved, or switched owners, but—as Michael wrote—"the true creatures of the night were constant." His subjects ceased to be subjects and became friends. Soon he was familiar with their fervent personalities, their dress, and the unwritten social codes for drinkin', dancin', and romancin'. The rules outside the doors didn't apply once you were inside the club. Everyone could be anyone. Class and gender lines blurred, and Michael's camera captured the glorious chaos.

Black folks love documentation. We covet curled-corner Polaroids snapped in the heat of dance while we reel beneath mirror balls in various stages of sweat. We pose outside the club the day before or the day after, squinting into an unforgiving sun. We grin in fur, silk, or sharkskin, smiling as we lean against gleaming Caddies that may or may not be ours. And Michael Abramson was there, as subtle witness, capturing who we were both in and away from the light. Michael loved it.

When I first saw these photos, even though I lived across the city from these South Side hot spots, I saw my father, my cousin Jimi Lee, and all the folks who worked at the candy factory with my parents, whirling to shrug off the workday. I saw Terrell the barber. I saw the women who worked behind the counter at the butcher shop, their aprons muddy with blood. I saw pump jockeys and schoolteachers, clerks and criminals. I saw the sacred space where they all came together in the name of spirits and sweat.

Like Michael, I hungered to walk through those doors to live there for a while. I already knew the music. But I hope I can make the pictures speak. Many of the people at these clubs, captured so deftly with that curious lens, were those who settled in Chicago from the southern United States. They traveled from Mississippi, from Alabama, from Tennessee, from Arkansas, bringing that relentless blue music with them. We have such a tenuous clutch on their histories—especially this part of those histories, where they were not trailblazers or pioneers or political statements. In the clubs, where practically every one of the faces mirrored their own, they remembered joy.

It means the world to me to see these smiles, to sense the rhythm of their bodies, to witness that particular type of love. To me, Michael Abramson's searing images are not merely pictures—he not only chronicled a history, he opened another door into my own.

CityFiles Press and the producers of this book would like to thank:

Michael Abramson, for what he saw, preserved, and left for us.

Patricia Smith, whose beautiful words and rhythmic phrasing bring Michael's pictures alive once again.

Midge Wilson, Michael's longtime partner and estate manager, who has shared Michael's work with the world since he passed away in 2011 at the age of sixty-three.

Michael's family, including his mother, Ethel Abramson, and brother Richard and especially his sister Leslie Abramson and niece Hannah Rossman, who entrusted Midge to fairly distribute Michael's belongings, preserve his photographs, further his legacy, and establish the Abramson Arts Foundation.

Otis Douglas Smith, Patricia's father, who—with the blues growl and a flashing gold grin—taught her how to tell a story and how to drink many an unsuspecting man under the table.

Bruce DeSilva, Patricia's husband, a paragon of patience as she dove into this irresistible project; son Damon, who every day shows the rewards of persistence; and granddaughter Mikaila, who sadly will never get to experience Chicago as it was or the clubs as they were.

Rick Kogan, columnist for the *Chicago Tribune*, for his 2007 article regarding Michael's South Side work and for so generously offering to write Michael's insightful obituary.

Tom Lunt, cofounder of the recording label Numero Group, for his unwavering support of Michael's photography. He created *Light: On the South Side,* a book of Michael's photos with two LPs of music from South Side clubs.

Kristin Basta, for her curating and writing skills in addition to her precise inventorying of Michael's photographs scattered around the large loft in which Michael lived for nearly thirty years.

Anne Zakaras and Anna Cable, for scanning and identifying the negatives used in this book. Sue Bradanini Betz, for her copyediting. Karen Burke, Caleb Burroughs, Claire Cahan, Cate Cahan, and Mark Jacob, for taking a last look. Gary Hawkey and John Bailey, of iocolor, for producing the book.

Tom Cinoman, former student and closest friend of Michael, who along with his wife, Margie, continues to support Michael's work.

Jonathan C. Logan and Reggio McLaughlin, who remembers these days and helps keep the memory of the clubs alive.

Patricia Smith is the author of six books of poetry, including *Shoulda Been Jimi Savannah,* winner of the 2014 Rebekah Johnson Bobbitt National Prize from the Library of Congress; the 2013 Lenore Marshall Poetry Prize from the Academy of American Poets; and the Phillis Wheatley Book Award. Smith also authored *Blood Dazzler,* a finalist for the National Book Award, and *Teahouse of the Almighty,* a National Poetry Series selection. Her work has appeared in *Poetry,* the *Paris Review,* the *New York Times, TriQuarterly, Tin House,* the *Washington Post,* and in *Best American Poetry* and *Best American Essays.* Her contribution to the crime fiction anthology *Staten Island Noir,* which she edited, won the Robert L. Fish Memorial Award from the Mystery Writers of America for the best debut story and was chosen for *Best American Mystery Stories.* She is a 2014 Guggenheim fellow, a 2012 fellow at both MacDowell and Yaddo, a two-time Pushcart Prize winner, recipient of a Lannan fellowship, and a four-time individual champion of the National Poetry Slam. She is the most successful poet in the competition's history. She is currently working a volume combining poetic monologues and nineteenth-century African American photos. Smith is a professor at the College of Staten Island in New York and an instructor in the MFA program at Sierra Nevada College in Nevada.

Michael Abramson (1948–2011) worked as a Chicago-based commercial and documentary photographer for nearly four decades starting in the 1970s. His work appeared in *Time, Newsweek, Forbes, Fortune,* and many other publications. Abramson grew up in South Orange, New Jersey. He earned a bachelor's degree in economics from the Wharton School of the University of Pennsylvania and lived briefly in Boston before moving to Chicago to attend the Institute of Design of the Illinois Institute of Technology. He began photographing South Side nightlife around Christmas 1974. During the next two years, he was inspired by the work of Brassaï, the photographer of nocturnal Paris, and became determined to show the continuity of nightlife. The South Side clubs were a link to Parisian bistros, Brassaï's "secret, suspicious world closed to the uninitiated." What interested Abramson most was the dress, gesture, personal relationships, and objects he saw in the clubs. The photographs he took was part of his master's thesis, "Black Night Clubs on Chicago's South Side." He received a grant in 1978 from the National Endowment for the Arts. Some of these photographs first appeared in *Light: On the South Side,* a 2009 book by Abramson that was part of a record package nominated for a Grammy Award.